Bird of Paradise

Bird of Paradise

Glimpses of living myth

MONICA FURLONG

MOWBRAY

Mowbray
A Cassell imprint
Villiers House, 41/47 Strand, London WC2N 5JE
387 Park Avenue South, New York, NY 10016–8810, USA

First published 1995

British Library Cataloguing-in-Publication Data
A catalogue entry for this book is available from the British Library.

ISBN 0–264–67336–0

The poem 'There is a New Morning' on pp. 130–1 is reproduced by kind
permission of James Kirkup.

Typeset by Fakenham Photosetting Limited, Fakenham, Norfolk.
Printed and bound in Great Britain by Biddles Ltd, Guildford & King's Lynn.

Introduction

Driving last year in the red wilderness of Australia's Great Sandy Desert, again and again I was surprised by the sudden arrival of a flock of budgerigars, flying in perfect formation. Startled at the sight of the truck, they would turn, the sun would flash on their emerald wings, and then the vision would be gone. Jung, I remembered, said that the moments the eternal erupted into the transitory had been the best moments of his life. George Herbert, writing about prayer, notes the same eruption:

> The Milkie Way, the Bird of Paradise,
> Church bels beyond the Starres heard, the Soul's Blood,
> The Land of Spices, something understood.

(Some versions prefer 'the Milkie May', and I like that even better.)

I had gone to Australia because I was interested in Aboriginal peoples, and was particularly fascinated by their attitude to myth. In many different ways—stories, song, rituals, sand paintings, body paintings, bark paintings, dances, and nowadays in print—Aborigines continually recall the adventures of the sacred ancestors of the Dreamtime who created the world. In their journeys, their quarrels, their making love or giving birth, these primal beings shaped the landscape, and the landscape is to Aborigines the living cathedral which symbolizes faith. It is there the sacredness is experienced, and it is there that sacredness is, as it were, reinvested by living Aborigines. Bruce Chatwin quotes Aborigines speaking of 'singing up the country', i.e. helping to bring it into continued existence. There is a flowing backwards and forwards between the past and the present, and endless interaction between the myth and those who live it. I remember Nancy asking us to stop the truck on a bit of track that looked to 'whitefellas' like us much like any other. 'This is where the Two Goannas passed on their journey to the sea', she said. And she

1

proceeded to tell us the story of the Two Goannas. Nancy's family had an intimate connection with this particular story.

What I was hearing was a living myth, a myth that had not become separated from the life of Nancy and her family. The myth makes it possible for an Aboriginal tribe or language-group to understand its life collectively, and also, sometimes through the vision of a shaman, sometimes through a more general understanding, to shape its future. It is a visionary, or questing, power. At the same time the myth itself seems shaped by or adapted to the temperament, preoccupations, hopes and fears of the people who live it and believe it. As in dreams the characters of the myth are the characters of daily life transformed—in the case of a hunter/gatherer people that means animals, plants, rocks, waterholes, as well as other people.

Because of its particularity, myth is not easily borrowed. If I, a Westerner, tried to live out Aboriginal myth as an Aboriginal lives it, it would not work for me since it does not arise out of my experience, nor out of that of my forebears. A myth usually needs to be nearer home than that, both in terms of geography, but also in terms of experience.

Myth symbolizes the sense of meaning of a person or a people; it lives while it still suggests meaning to us, and it dies when we abandon it. Observing the kind of split among white people between their myth and their lives, Aboriginals have often decided that white folk had no myth:

> White man got no dreaming.
> Him go 'nother way.
>
> Muta, a man of the Murinbata people

In fact, in the West we have had many myths—Norse myths, Greek and Roman myths, Celtic myths—a lot of which we still tell as stories and which still influence us, at least as fragments of our awareness. The myth that, for hundreds of years, has dominated the Western imagination, is the Judaeo-Christian myth. It is about a sense of sacredness that overtook a people and slowly forged an identity for them. Bound on a sacred quest, Abraham left Ur of the Chaldees. On another sacred quest, Jacob also experienced sacredness, was physically wounded by it (the dangerousness, as well as the wonder, of the sacred is well understood by the Patriarchs), but, like a true

shaman, discovered for Israel the identity it needed. Moses led the Hebrews out of Egypt and was overwhelmed by the experience of sacredness in the burning bush, on the mountain of Sinai, and in 'the cleft of the rock'.

Within the sacred space of its own land and its own sense of chosenness, Israel cherished, as in a cradle, the history that felt so meaningful, and the potential sacred future. Within the developed ethical and spiritual ethos of Israel the ideas of Jesus took root, and eventually spread far beyond Israel. The response that Jesus evoked in people seems to have been a sort of *recognition*. People met or heard about Jesus and thought, like Simeon or Anna, that this was what they had been waiting for. Jesus showed forth the sacred. Perhaps the distinguishing mark of the sacred is that the questions die on our lips, not out of propriety or fear, but because experience suddenly makes them irrelevant. The life of Jesus matched an inner myth which was already seeking an outward shape—the shape of a human being capable of great love, who was wrongly killed or sacrificed, but who could not be destroyed.

Out of the series of stories about Jesus came a structure—'the Church'—in all its many forms. The Church saw its task to be that of the container or sacred space holding the power of the stories within it. It retold the stories repeatedly and it held rituals (in particular the Mass) which take us back into a re-experiencing of the central story. The container-Church, over the centuries, has found innumerable forms to show us the sacred—we have been taught our myth in centuries of magnificent painting and music, sculpture, stained glass and architecture. From the myth sprang ideas which significantly affected our laws and medicine and science. Christianity has been *our* major myth, the way we have understood our life collectively.

Christians in general do not like the analytical process of examining their beliefs as 'myth', often contrasting this, wrongly in my opinion, with a conviction that what they have is 'the truth', i.e. something nearer to 'how things are' than the religious ideas of other peoples of the world. They dislike the idea for two reasons, I believe. One is that to discover truth reposes in something as shifting and apparently precarious as myth makes everything feel uncertain. As twentieth-century people we like the feeling of control, and opening

3

oneself to the myth is, has to be, a partly uncontrollable process. Yet maybe it is in something as flexible as myth, that is to say something alive, that truth, wisdom, creative change, and, fleetingly, certainty, are to be found.

But it means recognizing that 'our' truth, our myth, may not be someone else's. The Navaho Indians (and many other tribal organizations) think and speak of themselves as 'The People', i.e. as a specially chosen group. Like the Jews, or the Christians, they feel that their vision is unique. Which it is. But others must be allowed their specialness too. If Bonhoeffer's phrase about a spiritual 'coming of age' has meaning, then it must include putting away the childish omnipotence which assumes we are more important than others.

Some modern Christians, of course, those with a particularly acute sense of the gap that now exists between our myth and our lives, see myth as a primitive form we have outgrown. 'Our beliefs are only myths', says the 'Sea of Faith' writer David Hart, 'stories that attempt to illuminate our situation' (*Faith in Doubt* (1992), p. 138). David Hart, though not a conventional Christian believer, is using the idea of myth as most conventional Christians use it, i.e. a charming story, a downright lie, or an exploded fiction, an idea which, in Christian discourse, is often set over against immutable truth. Hart does not believe in immutable truths, but he does not set much store by myth either.

I do not share his view of myth. I want to suggest that when we speak of myth, or of the dominants or personae of myth, the archetypes, or of stories which, from epic and opera down to the silliest soap opera and the tritest comic strip, embody myth, we are speaking of something of immense importance, probably the most important thing in our lives. This can become obvious to us as we watch how myths drive and energize whole communities—for good or evil. In the myth of the Master Race evoked by Hitler, and in the myth of the Jew as the stereotypical 'other' that led innumerable innocents into the nightmare of the Holocaust, in the myths of tribal religion evident in Bosnia or Northern Ireland, in the myth of the witch that sent thousands of women to the flames in seventeenth-century Europe, we recognize huge energies which drive and compel. To speak of this as 'only' myth is like speaking of 'only an avalanche' or 'only a tornado'.

Once we have recognized the huge power of myth it becomes impossible to despise it, or even to imagine that we can escape its

power. What might make us better able to understand and avert the tragedies myth can cause, and use it to promote health and healing, is to understand more of its inescapable force and to recognize its working in our own lives.

What is this dynamism which works within communities and individuals, and where does it come from? I no longer think of myself as 'a Jungian', though I did once, and I am uneasy about the Christian attempts to adopt Jung as an ally, as if he was a Christian *manqué*, which I don't believe he was. Nevertheless, he has very interesting and valuable things to say about myth. Echoing and developing William James, he says that human beings have two kinds of thinking. One kind, 'directed thinking', involves a particular sort of concentration, and is the result of centuries of education. It is the fruit of rationality. It has, Jung suggests, produced a 'readjustment of the human mind to which we owe our modern empiricism and technics' (*Symbols of Transformation*, p. 16). Science has been the most distinguished fruit of directed thinking. (Jung's 'two forms of thinking' are probably identical with what we more familiarly nowadays call right- and left-brain thinking.)

There is another form of thinking, dependent on fantasy, or what William James called 'spontaneous reverie', which Jung describes as 'dreaming', whether of the night or day kind. This archaic thinking deals in 'primordial images': 'It seems to me that their origin can only be explained by assuming them to be deposits of the constantly repeated experiences of humanity' (*Two Essays on Analytical Psychology*, p. 68). Jung believed that 'archaic thinking' was close to the everyday thinking of some earlier civilizations, such as the Greeks, though we may observe it still today in the culture of peoples relatively undisturbed by 'modern' civilization, such as the Australian Aborigines. We also observe something very like it in the thinking processes of children. 'Through all our lives we possess', says Jung, 'side by side with our newly acquired, directed and adapted thinking, a fantasy-thinking which corresponds to the antique state of mind' (*Symbols*, p. 28). It was to this archaic thinking that the 'primordial image' of God belonged.

Modern thinkers often have a bias against archaic thinking, believing that 'directed thinking' is an improvement on it, and that we have

5

outgrown the need for archaic thinking. It is true that 'directed thinking' is efficient at the accomplishment of certain tasks, but the richness of many civilizations which did not think in this way suggests that there is loss as well as gain in the shift. What the 'archaic' kind of thinkers know about, as children often seem also to do, is 'the numinous', 'the sacred', the sense of total participation in their world rather than alienation from it. It is this sense of the numinous and the sacred, and the occasional moments of ecstasy and at-one-ness with the world, which gives religion its great power and which makes even suffering and loss bearable. For example, it is this sense of the healing power of the numinous that we find in the definition of the Greek word 'catastrophe'. In Greek music there were two stresses—'strophe' and 'antistrophe'—but occasionally, it was said, the gods themselves took a hand in the melody, and though the notes were at first harsh and dreadful to human ears, at length they were seen to be an essential part of the music, indeed to be the most marvellous music of all. This was 'catastrophe'.

It may be that 'archaic thinking', the using of 'the primordial images', is as vital to us as humans as 'directed thinking' is vital for the accomplishment of certain other tasks—for example, using an antibiotic to cure a disease. It is necessary that we recognize, and keep on recognizing, certain deep truths or myths within us and it is an instinctual understanding of this that keeps us so fascinated by stories. They are indeed clues, not just to everyday experience, but to the contents of the huge depths within us. Without this depth our thinking can lack a sense of feeling or rootedness.

One of the confusing things about archaic thinking is the power of projection. In a film star, a pop singer, a princess, or the person we love, we may catch a glimpse of what we recognize as sacred—that which cannot be argued with. Yet it is important that we recognize the force of our own projection. If the projection we are making is upon a siren, a demagogue, or upon an unpopular person or race, then only a shrewd recognition of the power of myth can avert tragedy. Even in a happy love affair we need some of this recognition.

A friend of mine who had grown up in the 1930s and 1940s in a sexually repressive family met a man when she was 40 who liberated her to her first passionate enjoyment of sex:

> There was an afternoon when I suddenly saw X [her lover] transformed. At one moment he looked just as usual. The next I perceived him with curly hair, pointed ears, with hair on his thighs and hooves instead of feet. 'Who are you?', I asked him. I began to tremble, and to be filled with terror at what felt like madness. Suddenly the word 'panic' came into my mind, a word which, oddly enough, I had never before associated with Pan. I knew that what I was seeing in X was the god Pan. But I had not had a classical education and had scarcely ever thought about Pan.

What suddenly became important for her sanity was recognizing the human vehicle of her vision: 'X was still wearing his watch, and I clung to that as a sort of clue to what was going on until I started seeing normally again.'

Divine powers, denied, have their own methods of re-asserting themselves. The great god Pan is not dead, *pace* Pascal, but was very much alive on that afternoon in the perception that a sane, twentieth-century woman had of her lover. Unknown to her until then, one of the dominants of myth, the archetype Pan, was vigorously active in her life.

Part of our problem, I think, is that, in the first flush of 'coming of age' we are ashamed of our non-directed thinking, which seems to us primitive, childish, and, in some views of the matter, 'female'. (Through lack of formal education women were deprived for centuries of the disciplines of 'directed thinking'.) Rational thinking feels modern, grown-up, male. The psychiatrist R. D. Laing said back in the 1960s that 'We are an age that represses transcendence', by which he meant the capacity to confront our powerful sense of divinity.

The Sea of Faith school seems to say that the God many experience within is less a real God than the God believed to be 'out there'. We may become ashamed of calling our experience 'real' if we see this as a loaded word. Yet what are we to do if the Divine, the numinous or the sacred seems so much more alive than much else in our lives?—somewhat as a brilliant stage performance feels much more alive than a poor one, even though both may be trying to point to an aesthetic truth. It feels an act of betrayal not to state that in some sense we 'believe' in what has happened to us. We may avoid calling this God 'real', yet privately this may be what we believe. If this experience is not real, then nothing else is.

Without the idea of God, Jung thought that humans made the mistake of taking on the God-role themselves, with a consequent loss of self-awareness:

> The idea of God is an absolutely necessary psychological function of an irrational nature, which has nothing whatever to do with the question of God's existence. (*Two Essays*, p. 70)

Is it fair or true to equate the loss of the idea of God with humans taking on a God-role? I am not sure.

But I know that a religion that is not open to the numinous, to the terror, the adoration, the mystery of God, as well as to the full implications of catastrophe, is too dry for my taste, a recitation of propositions, a procession of men (mostly) in fancy clothes, an endless repetition of empty ritual. Congregations, with their customary good sense, show their sense that 'the glory has departed' by refusing to have any part in it, though the wistfulness for a religion that works is very widely evident. I too find myself moving away, almost in spite of myself, from an organized form of religion which seems to be dying, but I cannot move away from the idea of God.

These are the reasons I wrote this book. Experiences of the numinous, the sacred, have been important in my life, not because they were numerous or particularly unusual (such experiences are almost a commonplace, if that is not a contradiction in terms, and might be more common if we did not try so hard to cling to 'directed thinking'), but because they lent purpose and order to a not particularly orderly or exemplary life. Perhaps they also made it difficult to lead an orderly or exemplary life—there was always the sense of something more cosmic being at work than the tedium of everyday concerns comprehended. I felt a bit like the child in a Woody Allen film refusing to do his homework because he found out the sun was shrinking; except that the outcome felt more positive in my case.

I began by thinking that I wanted to write a book about images and symbols and metaphor. Or, rather, that there was a book about them that I wanted to read, only no one else seemed to have written it. I wished someone else would write the book—many seemed far better equipped to do it than I—but they didn't. Either they knew

something I didn't, or I thought I knew something they didn't and needed to write it down to see if it was valid.

What I had felt for some time was a narrowness, a confinement, in Christian statements, as if the house was becoming too small for the family it was supposed to contain, and an intolerable claustrophobia was setting in. Many sorts of denial seemed to be at work, not least the denial of the speed at which organized religion is losing adherents. Mention of this huge fact always seems to lead to a sort of whistling in the dark ('It is a great challenge'), rather than any recognition that something might be wrong. There seems a growing fear of change, criticism, and open discussion.

There are many ways in which the fear of dynamic change expresses itself, but I suppose the word that has come most often into my mind is 'literalism'—a determined lowering of the sights, an obsessional doggedness, a clinging to pedantic detail, together with a lack of creative and imaginative thinking. As in George Eliot's *Middlemarch*, it is the timid, passive-aggressive 'I don't know what you mean, I am not listening to you, and anyway I know better' attitude of a Dr Casaubon denying the hope and ardour of a Dorothea Brooke. The terror behind the literalism is of energy, fruitful change, life itself.

Literalism is closely linked to denial. There is rage and scorn against those who wish to challenge the *status quo*—a David Jenkins, a Don Cupitt, and women who have tried to change the Church's attitudes to women. There is punishment—usually by way of a with-holding of jobs—for clergy who contradict the official line—about war, or homosexuality, or God, or who speak out strongly in controversial matters—for example, the Act of Synod.

I am speaking here about the Church of England, which is the Church I know best, but I see other Churches doing their best to silence controversy, and to move towards a dead conformity. No one school or Church has the monopoly in literalism. Almost all the major divisions within the Churches show signs of it—biblical fundamentalists, traditionalists, those who think moral and ethical considerations are the essence of faith, or social and political *praxis*, those who cannot imagine there could be new insights about sexuality, feminists who seem unable to live with the masculinity of Jesus, the Sea of Faith in its mundane understanding of story and myth—all seem trapped in a place that makes Christian faith seem drab and small.

There has been, of course, simultaneously with all this, an increased interest in spirituality, meditative and contemplative prayer, and in the writers who are thought to be the experts in this field. It is too soon to assess the strength of this movement. Potentially a source of life and energy, and thus of revolution within the framework of faith, there is a danger of it losing itself in the maze and ending up by feeding the complacency of the *status quo*. I am disappointed at how little real challenge and subversion has emerged from the movement—its tendency seems to be quietist. Spirituality may, for instance, become a trendy industry of the 1990s, alongside the group and workshop industry, with degrees being given in spiritual direction, and a fat profit being made out of retreats. Perhaps the retreats are worth the money—I admire anything which helps us to step off our preoccupation with time and busyness and to create space to discover the inner depths, yet I worry about professionalizing one of the few areas of human life that has remained obstinately amateur. I am troubled too by the religious nostalgia of this movement—its preoccupation with Julian or Ignatius or the Celts or the Benedictines—I wonder how effectively it prepares people for a consumer society of which St Benedict could not have dreamed. What would a twentieth-century spirituality look like, and what special forms of contemporary delusion would it need to unmask?

I wanted to write a book that suggested a more energetic approach to faith, I was sure that it should be about myth, but I found that, despite repeated attempts, this book just did not seem to get written. I found that I was having an Alice-through-the-looking-glass experience, and that, as I set out to explore these abstractions, I would find myself walking back through the front door of my own life. Only very gradually did it occur to me that the writer in me had perceived what consciously I barely knew, which was that the metaphor or myth of my own life was more compulsive, at least to me, than abstractions about images and symbols. My story felt to me, as their 'testimonies' did to the Puritans, the key to understanding. Not that I did, or do, fully or even partially, grasp the extraordinary fact of being a living being, nor make very much sense of the particular experience of being Monica Furlong. It is more that, baffling as it is, there are clues to be gained within that experience that are not available to me

elsewhere. The outer clues that life gracefully offers us—the kinds that come to us by way of stories, art, relationships, work, nature —have to interact with my inner sense of meaning if I am to be able to make use of them.

I have had enormous joy from living within the Christian myth—it has helped me, a naturally timid person, to be bolder, more high-spirited, ruder, funnier, and to deal better with pain. I think I have laughed more than I might have done otherwise. Sometimes Christianity has seemed to me, like Falstaff, to be a 'cause of wit in others'. There is an irony inseparable from religion—due to the incongruity of nature and divinity—that I enjoy immensely. Maybe irony is the distinctive quality of religious people, a quality that others only achieve by borrowing capital from those who struggle with religious faith. I know it can give a merciful perspective, and that religion is at its most ugly and dangerous when it cannot achieve that perspective. I wish I could say that I thought religion had made me better at loving—it has mostly made me aware that I am not very good at it, though I am still very interested in how it may be achieved.

Above all the sense of the mystery, the Other, has given a tang to life which I believe many would like to own up to if 'directed thinking' did not have them bound and gagged, robbed of the chance to explore what theologians and churchmen do not think good for them. The moment when the emerald budgerigars, or Herbert's glorious Bird of Paradise, flash across the landscape, are symbols of the timelessness of the sacred in our time-bound and ego-ridden lives. They indicate the transformation which is what religion has been and might yet be about.

I

Carrying a large yellow balloon, I was wheeled along the front at Margate in my push-chair. Suddenly the balloon burst. Just as I opened my mouth to cry, my mother whipped out a banana. 'See! Look what it's turned into!', she said. No wonder the world has always seemed a magic place to me.

'Who's the Holy Ghost?' I asked my mother when I was four. I had just attended my first Sunday school class and had been startled at hearing of the Holy Ghost—I worried a lot about ghosts at the time, mostly that they were lurking in dark doorways or under beds. My mother did not like that sort of question and made a face. 'You'd better ask Joan', she said. My sister was all of nine, and scarcely an authority on the persons of the Trinity herself, but whatever she said must have been reassuring, since I stopped worrying about the Holy Ghost. It was my sister who took me to Sunday school—I wasn't sure what it was, but I knew they gave you a little mother-of-pearl cross on a chain for going, and I badly wanted one.

I can only remember two things about Sunday school. One was the speed at which everyone else in the class found the hymns. A hymn number would be announced, and I would laboriously work my way through the book to find it—I had learned about figures at home. Everyone else seemed to find it immediately, whereas I had only just about got there when the hymn finished. I found it humiliating until, on my second or third visit, I noticed that, far from toiling their way to the right page, the other children simply opened their hymn books at random and la-la-ed their way through the hymn. Since few if any of us could read, it was as good a way as any.

The other interesting thing about Sunday school was my teacher, Miss Stone, gentle and sweet-faced, whom I loved. One week she left and we got another teacher. A month or two later my sister and I met

a woman in the street. She wore flowing black-and-white robes and a hood over her head. 'Look', said my sister, 'here's Miss Stone.' 'No it isn't', I said, though she did bear a faint resemblance. 'Yes, it is', said Joan. 'She's a nun now.' I couldn't bring myself to speak to her. I felt embarrassed by her strange change of costume—she wasn't *my* Miss Stone any more.

My parents sent us to Sunday school mainly to get my sister and me out of the way on Sunday afternoons, and maybe because people in the 1930s felt that a little religious teaching was the way to do the right thing by your children.

As a family we had a muddled religious history. My father, who was born in County Cork, was brought up as a Roman Catholic, like his father and brothers. His mother, Neni (pronounced 'knee-nigh'), who lived with us, was Church of Ireland, however, and all my father's sisters were brought up as Protestants, an arrangement my grandparents had decided on when they got married, one not uncommon in mixed Irish marriages at the time. My father had been a religious little boy, and for a while had had serious thoughts of being a priest. Once, however, the village priest had asked 'What happens to all the people who are not Catholics?' And the class had parroted back 'They go to Hell, Father'. 'It worried me', my father said. 'Thinking about my mother and sisters.' Also, he said, 'I didn't like the idea that the priest was supposed to be different from other people, better. I didn't want that.'

My grandparents emigrated to England with their big family, and settled in Westminster where my father was present when they consecrated the new Cathedral and later served Mass there. At the age of 17 he met my mother—his sister was married to my mother's uncle. My mother was five, and my father sat her on his lap and told her that she was very pretty. It was not the beginning of their romance—all he could remember of that first meeting, except thinking what a pretty child she was, was that she ran ceaselessly round and round the garden. 'Where did all that energy go to?' he would ask her teasingly in later life.

Returning from the First World War, my father began working in his brother-in-law's business, where my mother also worked. She was a strikingly beautiful young woman. The two of them fell in love and got married. For a while my father continued to practise his

Catholicism, getting up and going off to Mass on Sunday mornings, but gradually got out of the habit, perhaps because he loved my mother so much, and she was so scornful of religion in general, and Catholicism in particular.

There was something peculiarly compelling about my mother's cynicism about religion. The clergy were particular targets. 'All those women running after them!', she used to say. 'And don't they love it!' My mother had a nice line in cynicism generally. I remember walking down the Charing Cross Road with her and noticing the statue of Edith Cavell, the much-admired heroine of the First World War, who had helped British soldiers to escape. 'Who was she?' I asked. 'A silly bitch if you ask me', my mother replied. 'She asked for all she got.'

At least my mother's views were interesting and colourful, and often enlivened with hilarious stories. But for me there were no Bible stories or prayers lisped at her knee, and when she played the piano and I sang, it was not hymns but ' 'Twas on the Isle of Capri That I Found Her' and 'Red Sails in the Sunset', both of which I admired a lot. I still find myself humming the second when things are going well:

> Red sails in the sunset, far out on the sea
> Bringing my loved one, home safely to me.

Nice sentiments. A low-brow version of 'Blow the wind southerly'?

In 1925 my parents had bought a house at Kenton, near Harrow, in the new Canaan known to the estate agents as Metroland, a neat little house with a bow window at the front and french windows at the back that opened into a sizeable garden. The house had a 'front room' and a 'back room', two decent-sized bedrooms and one minute one. (It puzzled me when I was old enough to read children's books that none of the characters seemed to live in a house remotely like ours. They had pantries and shrubberies. They also had cooks and housemaids and nannies and went to boarding school, and this seemed odd too, since nobody I knew had a cook or a housemaid or nanny or went to boarding school. This didn't in the slightest affect my enjoyment of the books.) My parents paid just under £1,000 for our house, and called it 'Shandon', I think in memory of an Irish poem about Shandon bells which my father liked to recite. At first it was near to the country—my earliest walks were to

talk to the chickens at a local farm, or to pick blackberries. Soon, however, the country receded as the remorseless building spread.

My mother was a superb housewife without making anyone feel miserable with excessive perfection. Our week had a kind of immutable order about it: washing on Mondays, ironing on Tuesdays, baking on Wednesdays, house-cleaning on Thursdays and Fridays, large meals and going out on Saturdays and Sundays. My father worked a half day on Saturday, and there was always a sense of celebration when he came home at lunch-time, giving me the pink bit of the *News Chronicle*. It had the 'Arkubs', a strip cartoon which I followed avidly, identifying with the smallest character in it, a bear called Happy. There was a posh tea on Saturdays with the best lace cloth on the table, and the second-best cups—the best were saved for Christmas and family funerals—homemade jam, St Ivel cheese wrapped in silver inside a beautiful gold-and-purple packet, homemade sultana cake or orange cake; these last two have remained for me what an American friend always describes as 'soul food'. And on Sunday morning there was the rich smell of lamb or beef or pork cooking (chicken was too expensive, except at Christmas) and an apple pie or Eve's pudding to follow. I have a particular memory of sitting behind the King Edward daisies in the herbaceous border—it was very dusty but nobody knew where I was—on a hot summer day, and smelling the delicious smell of roasting lamb. I associate this, I am not sure why, with an apron Neni wore, of grey leaves interspersed with red cherries. Some of the best memories I have of my mother are of me sitting beside the kitchen table while she made pastry, or a sponge, or biscuits, giving me little bits of dough to play with, or the bowl to scrape out.

My mother also made most of my clothes, and tried repeatedly to curl my straight hair. Although we had little money, I was a well-dressed child, with everything I wore made by my mother, apart from a few nice things from a well-to-do cousin passed first to my sister and then to me. I would enviously eye some hand-embroidered dress my mother had made for my sister until it was my turn to wear it. I remember setting off for Sunday school on summer Sundays in a silk dress and a straw hat with flowers round the brim.

What I found uncanny about my mother, and it was nearly as uncanny when I was grown-up as when I was a child, was her intuitive

power. Introduce her to a new person, and immediately she could tell you all kinds of things about them that were not obvious to anyone else. When you got to know them better you found she had been right. It had an odd sort of spin-off. When my father was doing a crossword puzzle he would read out a clue to my mother and she would swiftly respond with an answer. 'Why?' he would say, unable to follow her reasoning. She could never tell him, yet frequently her answer was the right one. It may have been that, like a good Edwardian girl, my mother had been brought up to cultivate a silly, fluffy-headed image under the impression that this was what men liked (she could be maddeningly silly, it seemed to me, though she thought I could be maddeningly cerebral), but I am sure she genuinely could not explain her response to the clue. This was a matter of particular puzzlement to my father, who had as little intuitive capacity as it is possible for a person to have.

As a child, my mother's unerring perception unnerved me and made me feel horribly transparent, though it also increased my fascination, my sense of my mother as a bottomless mystery. I realized quite early on that I was the child of a sort of witch—a woman both beautiful and formidable—and that it was useless to try to conceal things from her. In spite of this I still tried desperately to be secretive about the things and people that were important to me, since my mother could destroy them (or at least my pleasure in them) with one devastating remark.

My sister and I were both baptized at the local Anglican church—it was the respectable thing to do. My real baptism into religion (and I suspect everyone else's) was of a very different and much earlier kind. My first memory is of sitting in a big pram outside the front door of our house and discovering with a tiny shock (I think of pleasure) that I was I. Before then, it seems to me, I had existed in what anthropologists call *une participation mystique* with the world around me, existing interchangeably with my mother and perhaps with everything else. It cannot have been so very long after that I famously walked from the kitchen to the front door holding a bag of apples for ballast—even my mother remembered it—a serious step on the road of life.

Already I had a kind of private life, unknown to my mother only because it was outside the world she recognized, losing myself

temporarily in natural objects. I remember gazing at a rose and realizing that I was it, and it was me. Now, the same experience would have feelings of fear in it, but I remember that first memory of it as being full of bliss, part of the fabric of the world around me. The colour and scent of the grass after a shower of rain took me into the same realization. Smell, sight, touch, sound, taste, tenderness, pain, were all experienced as overwhelming. Rage, joy, frustration, pleasure, curiosity, were the kaleidoscope of knowing. My parents, in my earliest recognition of them, seemed numinous, huge beings of total power and beauty, whom I passionately loved.

What moves me about these early memories is the quality of the feeling that goes with them. I want to say a feeling of holiness, or of sacredness, but such words are already too contrived for the unselfconsciousness of the feeling (I wonder if 'holiness' is the word we apply later to experiences of unselfconsciousness). I have no other words, however, to suggest the quality of beauty and poignancy and realness and immediacy of what I am trying to describe. The very special feelings I had about the house—I still dream of it, and can still remember where most of the furniture stood—the objects, the people, were sacramental; in their being they showed forth for me what was holy. What was God.

Within the sharpness and precision of innumerable moments there was the tune or colour of eternity, a weightless burden of meaning. I think you will know what I mean. There was the power of the encroaching darkness as winter came on, damp, a little smoky, full of new smells. I associate this with the tanniny scent of ink on a visit I made to my sister's school-room. There was fire, the sharp contrast of light in the darkness, bare trees, the explosion of Christmas light—the chain of revolving reflections on a huge, red, humming top I loved. In February there was the melancholy yearning of the northern spring—the poignant singing of a solitary blackbird just before dusk, the aching purity of the snowdrop with its tiny broad arrows of green—and then the procession was on its way—almond blossom, crocuses, daffodils, whitethorn, may, tulips, roses. Then summer—living bathed in warm air, in contrast to the chilblains and frozen breath of winter. There was a marvellous pavement at what we called the 'Top shops' – where we went for less-frequent purchases and to explore the delights of Woolworth's

—that sparkled in the light and was thrilling to walk upon. No doubt it was made of some stone well known to builders and architects, but it felt to me like the threshold of the celestial city.

There was another side to the ecstasy—the agonizing, childish struggle to adapt to the adult world—hunger, disappointment, shame, helplessness, other people's cruelty, fear, pain. It was the other side of the coin of joy and wonder. At three or four years old I loved to decorate myself with beads and necklaces borrowed from my mother and Neni. I was wearing an array of these and admiring myself in my mother's wardrobe mirror one day, enraptured by my own beauty, when my sister arrived home from school. 'You look absolutely ridiculous', she said, shattering the narcissistic dream. At once, seeing myself through her eyes, I could see miserably that, yes, I did look absolutely ridiculous.

She, like my mother, didn't allow you any illusions. I learned to cast-on in knitting, and walked around the house and garden all day, casting-on, casting-on, until the needles were packed with stitches. 'I'm knitting', I said proudly to everyone. Knitting was a major occupation among my female relatives. 'No, you're not', Joan said. 'You can't knit!' I had known I couldn't really, but I minded having my pretence exposed.

There was a built-in pain in my relationship to my mother. I loved her so passionately, but quite early on sensed I was a disappointment to her. While I was a child this always felt like a riddle that I must find the answer to. Sometimes I was on the verge of finding it, it seemed, and sometimes my mother really did seem to like and enjoy me, but when I felt her once again beginning to reject me, I would cling harder, and this could make her verbally cruel. She hit me occasionally when I was small and provoking, but I did not mind this anything like as much as her scalpel of a tongue. She built her disappointment in me into a stereotype with several key stories or sayings that summed up my failure to be what she wished.

She remembered for years how I once disgraced her by refusing to leave a house where we had had tea, how I had thrown myself down screaming and kicking on the threshold. I had been enjoying myself and saw no reason to stop. Very annoying, no doubt, especially as my mother had been keen to impress the hostess, but I was only three at the time.

'I know which one of you is the better looking', she said once to my sister and me. Pleased with my appearance at the time, I began by assuming she meant me, though I felt disloyal to my sister. When I realized she meant Joan, I was deeply hurt. I loved her so much, thought her beautiful (which she was), and tried very hard—too hard—to be a good child of whom she could be proud. In my recollection, she spent little time with me in the years before I went to school, leaving me with my grandmother, who loved me dearly but was too old and feeble to give me all the time I needed. As a result I seemed often to be playing alone—my sister was at school—or wandering in the garden while my grandmother slept.

Verbally precocious—cousins remember me, coached by my father, reciting tongue-twisters in my high chair—'the Leith police dismisseth us'—I began to stammer, another source of annoyance and disappointment to my mother. Only years later did I realize that my mother had very much wanted her second child to be a boy—'I was going to call you Donald', she used to say pathetically. My parents did not feel they could afford a third child, and in any case my mother found childbearing terrifying, so I remained a kind of walking reminder of her disappointment. Somehow, she linked my supposed inadequacies to my Irish blood.

'You're so Irish!' she would say whenever I irritated her either by my laziness and untidiness or by my ceaseless chatter. (I thought then, as I think now, that talk is one of the cheapest and best forms of entertainment going, and perhaps this really does declare my Irishness, since the English are much more miserly with speech.) Irish was only a shade better than Jewish—not that she could afford to be superior about that. Since my only knowledge of the Irish at the time was my father, whom I loved intensely, and his siblings, whom I liked, the insult rather missed its mark.

My mother's ambivalence towards me expressed itself both in a certain carelessness towards me—not bothering to get my teeth fixed—and also in an extreme protectiveness, as if guarding me from herself. At the age of six, when most of the children at school were still being taken to school by their mothers, mine let me ride two miles to school on a pavement bicycle, crossing one very dangerous road by myself. I was both proud of my independence and envious of the other children. But I never went anywhere without

endless warnings about the dangers of being run over, drowning, electrocution, and the approaches of strangers, all of which made me physically rather timid. The more urgent miseries of my life, the brutality of various teachers, never surfaced in conversation with my mother at all. I felt it would be a waste of time to tell her about it. Both of my parents, if you tried to tell them you were unhappy, had a way of putting on an expression that meant 'this is much more painful for me than it can possibly be for you', and I quickly worked out that I was only allowed to tell the good news.

I loved my father very dearly and drew enormous security from his pride in me. He was funny, with a huge fund of jokes, puns, stories. He was a terrific talker, and he loved a good argument. Despite rather poor health, he was almost invariably cheerful, a precious quality in a parent. He had a fierce temper, so well controlled that I can count on one hand the few times he ever let it loose on us. I rather liked it when he did get angry. It ruffled the too-perfect surface of the 'happy family', and felt more truthful than some of our family dialogues.

He had an extraordinary memory, often for entirely trivial details —in old age he could remember the names and addresses of seaside landladies in boarding houses stayed in many years before, and he knew an immense amount about politics, particularly Irish politics. Unusually for a man of the period, he thought nothing of giving a hand with the washing-up, or helping to get a meal, or looking after the children. A precious early memory is of my being carried home from the bus, and then very gently undressed by him, as we returned from some family outing. He had a strong feminist sympathy. From a later date I remember his outrage that women had been deprived of the vote for so long, and his pleasure in recounting the adventures of the first women returned to Parliament.

In my early childhood I was always in bed when he got home from work, eagerly awaiting his return. After giving my mother a kiss, he would come up and talk to me for a bit as I lay in bed. Now and again he would have a small present for me and for my sister—a tiny pair of binoculars, a kaleidoscope, a pencil, a peach.

However, like all of us, he wasn't perfect. In his wish to please my mother he was sometimes guilty of weakness. I felt angry that when she was unjust to us, and I could see that he thought she was unjust,

he never demurred. I suppose he saw it as loyalty to her, but it disappointed me. It took me years to see that his relationship to my mother was not altogether unlike my own. While knowing him to be a good husband and a kind man, my mother seemed disappointed in my father, and she took it out on him sometimes in cruel remarks that plainly hurt him. Dimly sensing all this, I longed to make it up to him. Years later she said to me, in one of her rare, but special, moments of truth, 'He should have been stronger'.

My father's Catholicism rarely surfaced, except in stories of priests and Catholic teachers who had been important figures in his youth. The Furlong family had left Ireland because my grandfather had a fracas with a tyrannical priest who terrorized the whole village. He was a rare man, Michael Joseph Furlong, a Waterford man, intelligent, and self-educated. At twelve he had run away to sea and had sailed round the Horn twice before he was seventeen and went home to see his mother. He was popular with the English ladies who went to Ireland to sail in the summer months, and made part of his living by crewing for them. They thought him tremendously good-looking, though in the photographs he is so covered in whiskers that it is hard to tell. He was a good actor and singer, a confident man and an articulate one, and he took no nonsense from the local priest. 'I'll see that you never get another job around here', the priest had apocryphally said. He never did, and that was why the whole family had left Scull, their beautiful seaside village in south-west Ireland, where they ran barefoot in the fields, and come to live in a London slum. My father was eight. 'That must have been terrible', I said, in a sudden moment of insight, a year or two before my father died. 'It was', he said, his face full of pain. My grandfather died a few years later, some say of asthma, some of alcohol.

A more comic story—not that my father saw it that way—was about the time he told Neni he wanted to marry my mother. He was Neni's youngest child, and her best beloved. 'You are too young to get married', she told him. He was thirty-two at the time! 'If Our Lord was old enough to be crucified, then I am old enough to get married', he had replied, and he was scandalized when I laughed at the story. As my mother might have said, 'So Irish!'

My two grandmothers were important to me. Neni, already 80 when I was born, sang to me and told me stories and held me in her

arms when I was ill or needed a cuddle. Much of my mothering came from her. Fairly early I picked up tension between her and my mother. Neni, it seems to me looking back, did more than her share in childcare and household tasks, but she was growing frail and forgetful within a few years of my birth, and by the time I was six had become seriously senile. My mother had had to contend with living with her mother-in-law all her married life, and by the time I was born needed space both in her home and her marriage. A further complication was that my sister and Neni did not seem to get on—I felt acutely distressed when my sister locked Neni into the cupboard under the stairs one day when my mother was out. I could hear Neni's pitiful cries but could not reach the handle to let her out, and I found it all terribly upsetting. I also remember another occasion of a row between my mother and Neni, my father agonizing between the two of them, in which I felt somehow I must be at fault because part of the quarrel had to do with the fact that Neni looked after me. The adults look strangely distorted in this memory, and there is a weird blue light over the whole scene, which makes me feel I must have been very disturbed by it indeed.

I visited my maternal grandmother, Nan, at Richmond once a week, and sometimes stayed with her and Gig, my grandfather. One of my earliest memories is of sitting on the scrubbed wooden kitchen table while Nan removed my leggings and I sang to her 'My Bonnie Lies Over the Ocean'. 'My, that's a sad song', she said, surprising me because I had not thought about the words at all.

> Last night as I lay on my pillow, last night as I lay on my bed,
> Last night as I lay on my pillow, I dreamed that my bonnie was dead.
> Bring back, bring back, bring back my bonnie to me, to me,
> Bring back, bring back, ...

Yes, that's a sad song all right.

In the Victorian sitting-room with the Nottingham lace curtains, the aspidistra, the lustres and ebony vases on the marble mantel, the smell of coal smoke and my grandfather's cigar, there was an extraordinary peace. They sat still, my grandparents, appearing to have no sense of pressing tasks to be done. They gave me all their attention as I chattered interminably about myself, and they made me feel loved.

Occasionally we went for sedate walks along the Thames, a stretch of the river that still feels like sacred ground to me. I used to puzzle about why their house felt so different from ours, with its pastel colours and Japanese vases and dried flowers. It was another world. Even the housework was different, Nan boiling up all the washing every Monday morning in a built-in 'copper' in the scullery.

Nan, of Jewish descent, a wonderfully satirical, subversive, loving woman, now seems to me to have been raging against some desperate sense of exclusion. I sensed that while my mother certainly loved Nan, who herself had some of my mother's charisma, and was devastated when she died, nevertheless both my parents very slightly looked down on Nan and Gig; that their determined bettering of themselves and their children took place as a form of distinction against them. I could never work out why this was, but associated it with Gig's frequent visits to the pub—a habit my parents were always superior about—and the cheerful drinking of Guinness and eating of robust food—pigs' trotters, pork pies, hams, maybe jellied eels —that went on around Nan's table. Yet this, like all our family tensions, never broke surface.

My mother, maybe picking up some of Nan's religious ambivalence, had many strange emotions around religion. I remember her coming once to church with me and sitting with the tears running down her face. 'I could never go there again', she said later. 'It upsets me too much.' But whatever upset her would not seem to go into words, except scornful ones. 'Look at the misery religion causes', she often said to me much later, puzzled that I could be drawn to religious belief. 'Look at Northern Ireland!' As always, she had a point, though it took me many years to bear her scorn of religion, and listen properly to her arguments. Even as a child, though, I think I sensed that she was a special case, and that this left me free to do my own thinking about religion. Either because of, or in spite of, her attitude to religion, I was deeply fascinated by it.

My parents, like so many parents, were 'good' parents, who tried their hardest to do their best by their children, working hard to keep us clean and healthy and nicely clothed on very modest means, taking us on an annual fortnight's holiday to the seaside, hoping that our lives might be easier than theirs had been. The deep hurts and disappointments, emerging from their own blocked hopes and lost

opportunities, were on a different level from the meticulous running of the household, and it was these which shaped their children in ways beyond their knowledge.

I found a wonderful consolation for myself in writing. Just after I had learned to write, and could still only do so very imperfectly, one of my two best friends—Patsy and Pat they were confusingly called, and both lived in houses across the street – came to spend a rainy afternoon with me. 'Let's write a story', Patsy said. She was older than me, and was helpful with the commas and full stops, which I did not yet quite understand. By the time we had stopped writing, an hour or so later, I knew, with a total recognition, that I had found something I needed.

'I like writing', I told my father that night. 'You could become an authoress', he said. It had not occurred to me before this that books were written by people, but at once 'being an authoress' was something I began to tell people I wanted to be. It alternated with another ambition of mine at about the same period which was 'to be a widow'.

Watching my mother endlessly busy around the house, her whole life arranged around my father and her children, I knew I did not want that. I helped her a bit with dusting and ironing and cooking, and I rather enjoyed all of that, but it didn't seem like a *life*. I knew, on the other hand, that I did not want to be an 'old maid', as people said then. My mother had a huge contempt for old maids, and my sense was that they did not look pretty nor wear nice clothes. So I looked around for another role model. They were few and far between in those days. I had never seen a woman doctor or dentist, nor a woman performing any professional job apart from teaching, and even that, I later discovered, she was forced to give up if she got married. A friend of my mother's whom I liked and admired was a widow, and it struck me that she did not have to tailor her life around a husband. She was the best role model I could come up with.

I was a premature baby. Years later I met by chance the midwife who had attended my birth. She said she arrived in the early morning to find my mother in tears. 'I don't want to have a baby', she sobbed. To which the nurse replied in the time-honoured manner of midwives, 'You should have thought of that nine months ago, dear'. But the birth was easy and I was born by noon.

I was, so my mother's younger sister has told me, 'a desperately delicate little baby', and I doubt whether my mother's adherence to the methods of the notorious Dr Truby King can have helped. I remember the copy of this 'bible' in the house. Innocently, I rather liked it because it had some pretty pictures of babies in it. I am inclined to believe, though, that my mother's healthy contempt for authorities and experts of all kinds may have encouraged her not to take it too seriously, and thus spared me the full horrors of the let-them-cry method of baby care. On the other hand, she took it into her head to feed me on cow's milk, something I cannot believe Dr King recommended—'Well, I'd done all that Ostermilk business for Joan, and I couldn't be bothered to do it again.'

I continued to be not a specially well child. (I wonder if any children were in those days—their endless sickness seemed taken for granted.) A severe spell of whooping cough when I was under a year old gave me a sort of asthma, which mercifully went away, and I had a horrible attack of measles at around four when I remember wanting to die. But my mother liked nursing the sick—I was never so cherished as when I was ill—and there were pleasant things when I started on my convalescence. An aunt sent me some wonderful transfers of fruit which were the envy of my sister. (Transfers were one of the best toys of my childhood, soaking a picture in a saucer of water until the picture peeled from its backing and you carefully 'transferred' it to a sheet of paper. The truly magic thing about the measles' set of transfers was that the picture that emerged on the paper was different from the picture on the transfer itself—an amazing mystery.) One day I was taken wrapped up to the window to wave to Patsy, a tiny white ghost across the street, who was getting over pneumonia.

Worse if possible than these sicknesses was the occasion when a dentist came to the house to remove some decayed teeth when I was three. (The good thing about it was that Joan was terribly impressed that I was 'having teeth out', something which had not yet happened to her.) Pinning me, fighting and struggling, to the bed in my parents' bedroom, he forced one of those rubber nozzles over my face and gave me ether to put me out. I think now that I thought he was going to kill me, and I find it hard to forgive my mother for not sitting with me to reassure me, though I well remember that the

medical wisdom of the day was to separate parents from children in the nastier phases of illness or post-operative stress. Incredible! I vomited for hours after I came round.

A recurring feature of life in the 1930s seemed to be the endless presence of sickness and death. A boy who lived across the road had died of diphtheria, and another, not far away, known to my parents, had fallen into the sludge at the local 'sewage farm' and been drowned. (This last was told to me as a terrible cautionary warning, though I was not at all sure what a sewage farm was at the time, and in little danger of tumbling into one.) A boy I knew at school was a living skeleton, who was brought to school in a wheelchair—he later died of tuberculosis—and another girl at school was crippled with polio, which we then called infantile paralysis. Illness and death seemed ever-present possibilities, and when my father needed a minor operation and had to go into hospital when I was eight, my first tearful protest about it was that he was sure to die. Mortality seemed very evident. Along with serious epidemic illnesses that could kill, or do serious lasting damage—diphtheria, scarlet fever, measles, whooping cough—tuberculosis was the recurring fear, and I vividly remember aunts and grandparents feeling my thin arms and worrying whether I was fat enough. My own children grew up in a very different world.

Formal religion, or at least an outworking of it, touched me not at Sunday school but at Priestmead Mixed Infants as we prepared for Christmas. The glorious smell of coldwater paste as we stuck the paper chains together blends for me with the words of 'Once in Royal David's City', which had a tingling, frosty feel. Jesus had entered my world and I liked the story—the family, the angels, the shepherds and the Wise Men.

Soon after came the 23rd Psalm. Nowadays I don't suppose they read it to six-year-olds – everything has been kiddified till the magic has been lost—but it delighted me. I loved the imagery of sheep and fields and hills, of 'lying down in green pastures', of sitting down to a table covered in good food, of being protected even when you knew you were in danger—the valley of the shadow reminded me of the long upstairs passage in our house where the ghosts and burglars lurked behind the doors to grab me as I tore past. I think the Psalm taught me a bit of what is meant by the comfort of religion. It was not

that the idea of God meant very much to me just then—rather the assurance that there was safety and kindness in the world, and I need not necessarily be overcome by its terrors, vivid as these were to me.

Soon after this we were taught the story of Saul and David. I loved this too—the singling of both Saul and David out as special people (I longed to be found special), and, just as important, the study of the desperate jealousy of Saul. I knew a lot about jealousy—I was horribly jealous of my sister, but I had not known that grown-ups were jealous too, or even that there was a word for this feeling. It helped.

I felt a different sort of jealousy there at school, where a seed was rather comically planted that took many years to mature. We had a percussion band with cymbals, triangles, drums. I wanted to play a drum but never got the chance to do so, as these were reserved for the boys. This seemed to me unfair, though I knew it was because the boys got stroppy if they were made to play the triangles. The girls, alas, never got stroppy.

There was another side to our Mixed Infant religion. The British Empire still spread large and red on the map, George V was solidly on the throne, and on Empire Day we took Union Jacks to school and waved them, accompanying this with suitable hymns and prayers. I loved waving the Union Jack, but dimly sensed, even at that age, some disjuncture. Was George V's God the same mystery as I had sensed in the garden? Probably not.

There was another disjuncture I suffered at that school. When I was six we had a teacher who terrorized us, tying children up, hitting them, forbidding them to visit the lavatory when they needed to. I had loved school, but became terrified of it, and developed a whole armoury of superstitious habits to protect myself against its appalling risks and humiliations. One day, out of sheer terror, I wet my knickers and a small puddle formed on the floor beneath me. The teacher, Miss Cook, pulled me out of my place and dragged me to the front of the class where she struck me hard, possibly harder than she intended because I fell over striking my head against a desk. For the rest of the morning I sat stiff with shame and fear, but when I went home at lunch-time I could not bring myself to tell my mother about the incident—I felt too ashamed. Eventually Miss Cook was fired—some children, braver than I was, had talked about her

tyranny at last. She was replaced by a young teacher called Miss Smith, who could not have been kinder or nicer. At the beginning of May she had us elect a May Queen, and to my delight I was chosen. The children came to school with armfuls of flowers and I was crowned queen. Much of the pain of Miss Cook's reign faded, but not all. At the beginning of each school year I used to wait terrified to know who our next class teacher would be—one of the nice, kindly ones, or a tyrant who would make going to school a misery.

When I was eight Neni died, and bequeathed to me a Bible she had loved that I thought was very special because it had wooden covers made out of cedar of Lebanon. I tried to read its minute print but got into difficulties almost at once. 'What does "openeth the womb" mean?' I asked my mother as I struggled with the opening chapters of Luke. 'Never you mind!' she replied.

My mother had started sending me to church on a Sunday with my sister. The service at St Mary's, Kenton, took nearly two hours—it was an Anglo-Catholic Mass, not Matins—and I felt suffocated with boredom. Sundays began with me weeping into the bacon and eggs, begging not to have to go. But I did. It was as inevitable as the drive in the car on Sunday afternoon (on which I always felt car-sick), the high tea we ate when we got home, and the games we played afterwards—whist and nap and Lexicon and Film Fantasy. Not all of it was bad. I thought the new white church was pretty and pleasing (and I still do), and I liked the singing. I can even remember a bit of a sermon about God receiving people's prayers and sorting them into different piles, though I cannot remember how He classified them. The sermon gave me a vivid picture of God, as it were, at His desk. I liked the incense and I was thrilled if the water in the asperges fell upon me—I used to try to persuade Joan to sit near to the aisle to increase our chances. But on the whole I longed for diversion, particularly in the form of anything ridiculous by which my family, as you will have gathered, was mercilessly amused. I still remember the Sunday the Bishop of the Windward Isles came and was hailed with an Anglo-Catholic pomp of processions and lace, fancy copes and incense that had my sister and me in raptures of amusement. The little purple cap the bishop wore under his mitre, in particular, I found exquisitely funny. Happily, my sister found it funny too. We

built the event up into a hilarious story which we described to our slightly bemused parents.

An event of far greater significance for me occurred in the year before the War when a beneficent municipal authority built a library on the corner of the road where I walked to school. The building was in a kind of Bauhaus style, with lots of windows and light polished oak that I admired extravagantly. Best of all there was a big children's section filled with brand-new books.

I think going into that room (we were taken as a class from school) and seeing and smelling all those books for the first time was one of the most delightful days of my life. I had by then nearly exhausted the meagre supply of books they had at school, and at home we had no books except Pears' *Cyclopaedia*, a book of humorous 'recitations' (I electrified a teacher once by reciting a risqué one of these in class), and several shelves of Dornford Yates-type novels. So it was thrilling to be enrolled in the library, and I borrowed a book called *The Secret of the Dusty House*—my friend Dorothy borrowed *Billabong's Circus* – and we all went rapturously back to school. You were only allowed one book at a time, and I used to call in every day on the way home from school, return my book and borrow another. Sometimes I could not wait until I got home to read it, and would sit on my bicycle outside the library reading it, but I still could not exchange it until the next day. The library remained for the rest of my childhood and throughout my adolescence my main source of education and of pleasure. During adolescence it became a holiday rendezvous for me and my friends. It was a marvel. We were all very much in awe of the chief librarian, Miss Dimbleby—said to be a relative of Richard Dimbleby—and when she once asked me, in my teens by now, if I had enjoyed a book (about Ruskin), and said she hoped to read it herself, I felt very proud.

A different friend was a priest from St Mary's called Father Edmonds who had become a buddy in my days there as a Brownie, and to whom I confided my dislike of going to church and my theological interests. He used to send postcards to my sister and me, and sometimes dropped in to see us all, somewhat to my parents' disquiet. My sister used to do very funny imitations of the posh way the priests at St Mary's talked, and even funnier imitations of the processions there, with nightdresses stuck on walking sticks (oh, we

were our mother's daughters!), but Fr Edmonds was such a trans-parently nice man, and took such a gratifying and kindly interest in us both, that we never mocked him.

Pat Rose was my closest friend and we played for hours inventively, trying to make ourselves stilts, fencing with bean sticks, climbing along the sides of a local brook, our feet only an inch or two above the water and occasionally in it, swimming, camping in the back garden, using a hammock as an aeroplane (and wrecking it), building a tree-house with a lot of help from Joan, eating enormous numbers of raspberries and Victoria plums, playing the ghastly Monopoly. I remember one slightly perverse game—invented, alas, by me—played with some other children, in which we took it in turns to tie prisoners to the wooden framework of the swing. I recognized that I found this exciting in a way I could not quite fathom—so did everyone else I noticed—and I wondered why.

Pat was pretty and funny, and a great speculator, as I was, about sex, babies, and similar topics. Neither of us were given any precise information—children weren't at the time—until we 'did' human reproduction in school at the age of about thirteen. We were both enormously surprised when the full facts emerged, I think because neither of us could envisage taking off our clothes in front of a strange man. When I was much younger my sister once claimed to know the precious facts for which Pat and I yearned, but she refused to tell us. 'It would only upset you', she said, to my fury. When I mentioned it to her a few years ago she said she is fairly sure she didn't know herself, but didn't want me to guess this.

War came and I took to praying at night that it would be over quickly and that 'not too many people would die on either side'. It was a vain hope, which showed I knew nothing of the horrors of war, but it felt like the best I could do. Every now and then there would be an official day of prayer and the churches would fill with people praying about the war. I overheard a regular churchgoer at St Mary's saying how wrong it was that these fair-weather prayers didn't come every Sunday. Because my parents never came to church I felt torn, as my father had felt torn on the subject of Protestants going to hell. Then, and since, I have had a soft spot for the non-churchgoers.

After the first few peaceful months of 'the phoney war', we were woken one night by the outrageous thunder of ack-ack guns echoing

and re-echoing in ear-splitting cracks, and the whistle and crash of falling bombs near at hand. We ran downstairs to reach a safer part of the house, and for the first time in my life I felt my knees literally knocking together in terror. In air-raids my father's calm and optimism came into its own. 'The bombs won't fall on us', he used to say. I knew it was nonsense, and unfair nonsense at that, but it comforted me just the same. At school we began to spend much of our time sitting inside large drainpipes in the grounds which were covered with mounds of earth. I suppose the argument was that if a bomb was dropped on the school we should be protected from the weight of the building and the dangers of glass and shrapnel.

Junior school was a sort of latency period for religion as for other things. Our headmistress was frankly a Communist – she stood as a candidate some years later—and had scant sympathy for religion but was, I think, bound legally to hold one 'assembly' a week. The only religious content of this was a brisk rendition of the Lord's Prayer, with frequent interruptions from her—'Stop doing that, that boy in the corner! Stop talking, you.' I privately judged her irreverent. In spite of terrible overcrowding—50 to 60 in a class sometimes—and some terrifying teachers and children—she built a good lively school that had a kind of energy about it I rather liked. It was physically frightening, but it was unpretentious, devoted to giving a good education to a huge number of children who lived in the uprooted world of Metroland. Poetry, stories, history, English grammar, dancing and singing were all well taught—arithmetic, science, geography rather less well. Mathematics terrified me for years.

Home, family, stories, songs, books, food, love and the rejection of love, hurt and humiliation, jealousy, fear, friendship, a love of writing, stammering, jokes, learning where babies come from—these are the straws of a life from which the future bricks of fear and confidence are made, though beneath all of them was some sense of the wonder and magic of the world. I wish I had had more confidence and less fear, but the important thing is that there was some love in it all, maybe less than I wanted or needed, but enough to keep me sane. The love and the magic, I knew later, were the same thing.

2

In the National Gallery in Washington there are four works by the didactic artist Thomas Cole, depicting the melancholy fate of fallen humanity. (Seen as male, inevitably, though I suppose the dire warning is meant to apply to both sexes.) In the first picture there is a merry little baby sitting in a boat with his guardian angel at the helm, and the two of them float happily through pretty meadows of flowers. In the second picture the youth has taken over at the helm, and has thrown the guardian angel overboard in order to steer the boat himself. Visible to us, but not to him, are an alarming series of whirlpools and rapids ahead, more or less guaranteed to wreck the frail vessel.

My movement from childhood to youth was marked by the rite of passage of going to the local grammar school, Harrow County School for Girls. Having heard my sister talk for years of her life there, which she loved, I knew about it in advance in enormous detail. I knew the nicknames of the teachers and of my sister's friends, I knew names of head girls, and prefects, of who shone in which games and who was clever, who sang beautifully or played an instrument with amazing skill. I knew about the uniform and at what age you changed from a navy tunic to a skirt and blouse with a school tie. It was rather like a favourite book, read so many times that you knew it by heart.

It was inevitable that the place would be a disappointment when I got there, and perhaps also a lesson that I was a very different animal from my sister. I felt a sense of confinement almost from the beginning. I felt confined by the uniform for a start. It seemed a very complicated outfit, that took my entire stock of wartime clothing coupons for the year, and needed a lot of cleaning and pressing and, in the case of the black stockings, darning. Shoes for gym had to be

Blancoed (surely quite unnecessarily). The tunic was actually quite heavy, with deep serge pleats, but what weighed on me more was suddenly having so many possessions I had to keep track of. At the junior school all my few possessions were kept in my desk and were left there at the end of the day. Most of our activities took place in the same room. Apart from bringing a pair of plimsolls for games, and, towards the end, remembering my gas mask, there was nothing to look after or forget. Now suddenly I had four different pairs of shoes to worry about, a science overall, and a large number of books which had to be carted around to different classrooms. For a while it defeated me, and I was always in trouble the first term for never having the right equipment or books with me, and sometimes for not even finding the classroom where I was supposed to be. (Friends will recognize my lifelong capacity for getting lost, usually in a fit of absent-mindedness. A couple of times—one night in Harlem, New York, and one afternoon in the Sinai Desert—my vagueness has brought me into actual danger.) I was elected form captain in my first term, which I found thrilling until it began to be used as a weapon against me. 'You're form captain', I remember my form mistress, who also taught science, remarking, 'and yet you keep forgetting your science overall?' Oh, petty, petty, petty.

Then, I missed the company of boys, though it took me a while to work out that I minded this lost ingredient. At my junior school, boys had provided a funny, confident, subversive quality—they were altogether bolder and naughtier than the girls, and I had loved to watch this. I had always sensed a potential prissiness among the girls, a tendency to try to conform to some stereotype of femininity—it seems to me now that parents and teachers alike encouraged this in them—which bored me because of its falseness. Boys might be rough, unkind, even violent, but they seemed good at being themselves, probably because to be male seemed to be all that was required of them. There had been a few male teachers around too whom I had liked. Difficult to say what they gave that differed from what some excellent women teachers gave, but it *was* different.

Now I was at the grammar school, and there were no boys and no male teachers and virtually no one I knew at the school except Pat, who was in another class, and my sister, who was a world away from me in the sixth form. The grammar school was not so much prissy as

prim, with extraordinary new sins, like going out in the street without wearing your hat, visiting the local sweet shop after school, or eating in the street (a particularly awful crime, this). I found these new sins both petty and baffling, mainly because I had not yet grasped the key that made sense of them, which was that this education was about turning you into something you were not, that is to say, a lady. The lefty education of Priestmead had been straightforwardly about giving a good educational start to children of a working- or lower-middle-class background. The grammar school education was about turning sows' ears into silk purses:

'Can I go now?' '*May* I go now?' 'He was hung.' 'He was *hanged*.' 'Diptheria.' '*Difftheria*.' 'Under way.' '*Under weigh*.' 'I will drown and no one shall save me.' (Or was it 'I shall drown and no one will save me'? I never quite worked this one out.) 'Not *less* cakes but *fewer* cakes', etc., etc. I do not think our teachers, with their emphasis on pronunciation, and on grammatical and semantic niceties, realized the political implications of their educational method. I enjoy correct English grammar as a precise tool in a beautiful language, and even idiosyncratic English spelling has its own charm. We did have valuable things to learn in this first encounter with university-educated people (if you don't count the clergy whose hilarious posh voices we mocked so unkindly). It was more that the unspoken assumptions of our education were less about knowledge and the freedom and courage and confidence of the mind than about learning how to 'pass' in the world of ladies and gentlemen.

I happened to enjoy, to be actually hungry for, many of the ideas the grammar school offered me, but I was puzzled by how disapproving teachers were about almost everything we or our parents did or enjoyed—Hollywood films, popular music, popular novels, slang ('Don't ever let me hear you use that word again, Monica', one of the games teachers said to me when I once replied 'O.K.' to some command of hers). I remember being taught how to do compound fractions with the formula that 'it was the opposite to the way you used your knives and forks at a dinner party', i.e. you began with the innermost brackets and worked outwards. None of us had ever been to the sort of meal where you had a large array of cutlery and had to worry about what order to use it in. When I did eventually progress to such an occasion, I worked out how to do it by remembering that it

35

was the opposite of compound fractions, which I suppose was one up to Harrow County.

The countervailing influences to our unfortunate backgrounds were culture, piety and wartime patriotism. The culture had some very good things about it. We had excellent teaching in English, Latin, history, mathematics, music, art, and, I daresay, science—I evaded that pretty early in my school career. Science could have been one of the places where a tactful guardian angel in the back of the boat would have been useful. I imagine him/her suggesting with a tentative cough that though I might dislike hanging out in a smelly laboratory and trying to draw those tiresome diagrams, if I 'gave up science', as we used to say, I might later regret the lost knowledge. Also—another tactful cough—it could even be that some science might interest me a lot, for example biology or botany. (Nowadays, these interest me a lot.) At the time science seemed so drab, so lacking in the poetry and panache of all my favourite subjects.

In my first term I went to a sixth-form production of *Twelfth Night* and fell head over ears in love with Shakespeare—or was it with the pretty, boyish girl who played Viola? It scarcely matters now. Long after her boyish figure and curls captivated me I still get a lot of pleasure from the old spellbinder. In fact, Shakespeare was one of the real treasures of that sort of education. By the time I left school I knew about ten of Shakespeare's plays really well, and had seen a number of the others performed. I had also read a lot of poetry from the seventeenth, eighteenth, nineteenth and twentieth century, and a rather limited number of classic novels. In Latin I had read Caesar, Virgil, Ovid, which I'd enjoyed, and Livy (an unspeakable bore). Our teachers believed girls should learn Latin, in imitation of the boys' public school system that was the blueprint of grammar school education, but for some illogical reason felt we should be spared Greek, an omission I have always regretted.

Unlike the junior school, Harrow County was pious. We had prayers every day, from which Jews and Catholics felt obliged to withdraw. There was a hymn, a Bible reading by the headmistress, and prayers. I liked the hymns—I can still feel the Advent thrill of 'O Come, O Come, Emma-a-a-nuel' or 'Brightest and Best of the Sons of the Morning', and remember the pleasant hot-weather feel of 'Summer Suns Are Glowing over Land and Sea'. I liked the Bible

readings too—I learned some marvellous bits of religious prose that way. What I detested were the interminable speeches of the head-mistress after the exercise of piety, harangues in which things like punctuality, tidiness, and, yes, wearing your hat in the street, all seemed caught up in the meaning of the Christian religion. I had a strong natural feeling for religion, but not that religion.

There were also 'scripture' lessons all the way up to School Certificate. I enjoyed 'scripture', and got a distinction in the exam-ination, but this was largely because I enjoyed the gutsiness and poetry of the Bible, and because theology is in my Jewish/Irish bones. What was offputting was that it always seemed to be taught by sad human beings for whom I suspected religion was a compensation for an unlived life.

Wartime lent a special intensity to school religion, not so much the intensity that any of us might die as a result of a bomb at any time, as that British life took on a sort of collective and sometimes mawkish piety. Sometimes this could feel inspiring and moving, as in Church-ill's speeches, which still move me as they did at the time, or George VI's famous quotation of 'I said to the man who stood at the Gate of the Year'. Perhaps these worked because of the obvious sincerity of the speakers—it was clear that Churchill and King George believed every word they said. Less genuine in feel, though always interesting, were J. B. Priestley's Sunday-night broadcasts. Like many who thrived on wartime sentiment, he was a tremendous old ham. Years later when I worked for the BBC as a producer and wanted to get an actor to imitate Priestley's sonorous Yorkshire accent, I found some old wartime tapes in the archives and listened to them. There was one broadcast just after Dunkirk when Priestley regretted the sinking of a 'little ship', the ferry boat *Gracie Fields* which had plied between the Isle of Wight, where Priestley lived, and the mainland.

'I like to think that the little *Gracie Fields*, in that great haven beyond the skies, is now plying to and fro ...' etc., etc. Wartime sentiment did get pretty cloying, but this was going a bit far, even in the perverse self-congratulatory mood that followed the catastrophe of Dunkirk. In my later years at school I sometimes skipped lessons and went off to the disapproved-of cinema. I must say many of the films were unbelievably mushy. Even my adolescent self could not stomach *Mrs Miniver*, rejecting the crude Hollywood prettification of

37

wartime life in Britain. I did love *This Demi-Paradise*, however, a story of a Russian engineer (Laurence Olivier at his most ravishing), who came to work in a British factory and discovered what friendly, quaint, dotty people the British were. The dotty British discovered in turn how lovely the Russians were (this was after Russia became our ally, of course). It did not take very long for them to turn back into 'nasty Commie atheists'.

A better entertainment was Dorothy L. Sayers' radio play sequence *The Man Born to Be King*, which moved me a lot as a teenager, especially the Crucifixion and Resurrection sequences. Even my mother was affected by them. The BBC was rather heavily Christian in those days, with a strongly Anglican flavour, and the broadcasting of Sayers' play was seen as a hugely brave action by the then head of religious broadcasting James Welch, not least because Jesus himself had lines to say. We were still in the straitlaced days in which the BBC were afraid to broadcast church services in case they were heard by 'people in pubs'. British public life so often seemed to reveal the primness I had noted and disliked in the grammar school, and I was already beginning to wonder at it. When I want to capture the essence of all that repression and solemnity, I find I can perfectly recall the hushed and obsequious tones Richard Dimbleby used to use when describing the inside of a church or cathedral, or a royal occasion of any kind. So much constipated good taste.

One of the good things about Harrow County was that there was much less open violence than there had been at the junior school—you never felt in danger of having your arm twisted, of being run down in the playground, or the garden as we had to call it, by someone twice your size, or having a teacher wallop you with a ruler. Physical safety is always a mercy. Not that we called them teachers any more—they were 'mistresses' or 'staff'. You weren't in a class, but a 'form', and you didn't have 'playtime', you had 'break'.

But I did feel obscurely disturbed by the fatal ambition at work beneath the surface. It took the form, on our teachers' part, of believing boys' public schools were the perfect flowering of education, and thus what everyone should aspire to. A devotion to the ideal of the Christian gentleman ('one who never inflicts pain', according to Newman, though he was a great inflicter of pain in his way) and thence to God, King and Empire, to games and classics,

and *mens sana in corpore sano*, was what it was all about. In singing lessons we were taught the famous songs of the posh school up the hill—'October', 'Willow the King', 'Follow Up' and 'Forty Years On', all of which, I must say, still move me today (they are marvellous songs), as does the Eton Boating Song with its comically homoerotic undertones—'Swing, swing together, your bodies between your knees ...' Behind the strange forms boys' public school education had taken were the influences of nineteenth-century evangelical religion, and also the need to train men to rule Britain's burgeoning colonies.

The trouble was (1) that we were girls, and (2) that we were of very different material from the boys at the admired public schools. Our teachers ('mistresses') were dealing with children usually of lower-middle-class background, whose parents had never had a chance to complete their education at all. And so there were all the social nudges and winks—what books, painting, music to admire and how to alter our speech so that it sounded less 'north London'. Yet by notching up our elocution (and I never consented to notch mine very far), and acquiring such pernickety standards of what was and wasn't said or approved, we were learning to despise our parents who 'knew no better'. (I remember a teacher who was fond of saying to us *'noblesse oblige'* as a reminder we ought to behave well. What can she have thought she was saying to us?)

Years later, when I read *Great Expectations* I recognized in Pip's fear of being let down by Joe Gargery—a man of greater intrinsic human quality than any of Pip's 'grander' friends—my own fear that my parents would let me down on their occasional visits to school, though in those days the division between school and home was mercifully wide. My father and mother were no less intelligent than any of my teachers, but they had left school at thirteen, and were thus cut off from the passwords of the society. It was these that we, their children, were being given, but at a price.

Just after the War, when there was a liberal headmaster at Harrow (I remember him making a speech saying that after the War there would be less of the clubs and diamonds and more of the hearts and spades), he invited pupils together in the Speech Room from all over Harrow. We all belonged to the Student Christian Movement, and for once this made it possible for public school and state school

youth to mix. After the official business of the afternoon, which included a speech from Geoffrey Fisher, then Archbishop of Canterbury, we were entertained to tea in small groups in the boys' houses. I found it all tremendously interesting. Twenty years later I developed a friendship with a man who I discovered had been at Harrow at that period and who had attended the meeting in the Speech Room. 'What did you think of us?', I asked him, since he said he remembered the occasion well. 'We though you were the most awful yobboes', he replied. And I had put on my best skirt, too.

It is not hard to see how all of us—teachers, parents, children—were caught up in a dream of Empire, C. of E., monarchy, class, the public schools. Religion, which might have attempted some radical critique of the system (Jesus, after all, was no gentleman), was at the service of this dream, as it was at the service of the war effort. Established religion, almost by definition, is on the side of power.

There was also some expectation that those of us saved from the factories should be grateful that, considering our origins, we were getting an education at all. To be a girl was, of course, to be relegated to the lower half of the lesser breed, and to be expected to be especially grateful, women's education being such a recent development. (And Cambridge was still not granting degrees to women.) Although tests and exam results showed we were as intelligent as the boys, we were tactfully led to recognize that our ambitions should not soar too high.

I am writing with a lot of hindsight. It seems to me that our teachers, like my parents, simply could not imagine a world in which girls could play any sort of leading role. The highest ambition to which a rare Harrow County girl ever attained was as a doctor or headmistress. Most were destined to be nurses, teachers or secretaries. Or, better still, wives and mothers—'a very important role' as my headmistress, who was neither, liked to say. At the time I felt vaguely that something was wrong, with, as I have said, an unpleasant sense of confinement at the role that was being so carefully mapped out for us as women. I was always delighted when I learned about women in 'real' jobs—politicians, journalists, writers, or who occupied senior positions at the BBC. My memory is that they were very few—I could count them on two hands—and that in law, the Civil Service, education, medicine, business, they were virtually non-existent.

Women like Barbara Ward, Barbara Castle, Edith Summerskill, Dorothy L. Sayers, Vera Brittain, Mary Somerville, felt very important to me, and I cherished every reference to these heroines in print (egged on by my father, who took almost as much interest in them as I did). I had no urge to emulate most of them, but it made all the difference to see women who had broken out of the confines of domesticity, and been recognized as able.

My role as a woman had already come home to me in another way. Noticing my breasts beginning to grow, I was both somewhat proud but also anxious at the change in the body I was used to. Maybe I wasn't the person I had thought? My mother gave me a little talking-to about periods. I felt quite excited at the idea—I was always one for new experiences—and dashed across the road to discuss it with Pat. When my periods started, I said triumphantly 'Now I can have a baby!'—we had got that far in the human reproduction class—and my mother, apparently fearful I might wander out in search of a mate that very afternoon, said 'Oh no you can't!' I was thirteen.

Perhaps because of my budding sexuality I fell in love a lot. (I say perhaps because I had been doing it since my first day in the infants' school when I fell in love with a fairy-like child—she had blonde curly hair and blue eyes—called Pat Edwards.) There were at least a couple of other girls I fell for at various times—my passion was always undeclared. And there were two teachers, one in the infants' school, one in the juniors'. It seemed to be a way of trying to give myself unreservedly to some quality I admired. I loved Pat Edwards because of her beauty, Miss Smith because of her kindness, and Miss Robins because of the way she read the death of Arthur. I still get a thrill at the words 'Then slowly answered Arthur from the barge'.

At the grammar school I fell in love first and foremost with the gym and games teacher, who had a sort of masculine beauty I found tremendously appealing. On one cold winter's day when there was so much snow that we could not play games, she took us for a walk on Harrow Hill. On a snowy slope there was a partially melted snowman who was still several feet high, and with a run and a bound she leaped gracefully over it. I was enchanted. Later I fell in love with the art teacher, who was young and pretty, where most of our teachers were, or seemed to me to be, old and dowdy. (I say 'seemed' because, a few

years ago, tidying out a cupboard, I found one of those huge school photographs, the kind where some witty child manages to appear at both ends of the picture, and I could not believe how young all the teachers (mistresses) were. When I had left school, I could have sworn they all had one foot in the grave. The change was a kind of miracle.) On the whole, though, they showed little interest in their appearance. I am not sure that any women nowadays look as they did—flat-chested, or very fat, poorly dressed in drab shapeless woollen dresses, their hair either cut unbecomingly short—what was known as 'the Eton crop'—or scragged up in a 'bun'. In some cases they wore 'bunion' shoes, or had whiskers. My mother, on her rare visits to the school, was scornful about their appearance (which I loyally defended—I feel less loyal now), and complained that none of them wore corsets. Certainly their whole turnout taught the lesson that women's appearance was wholly unimportant. I feared all university women must look like that.

Talking to women friends of my own age I find that nearly all of us formed this depressing picture of our teachers—a few years later it altered quite a lot, I think. Yet such was the need for female role models that most of us fell in love as schoolgirls, either with other girls we admired, or with the more attractive teachers, or, as I did, with both, yet little is ever said about this important emotional fact in the discussion of the education of girls, apart from scornful comments about 'schoolgirl crushes'. I suppose this is because of fears of lesbianism. It certainly raised fears of lesbianism at Harrow County, not in my own case because I kept my feelings largely to myself, maybe out of shyness, but mainly, I think, because the pleasure had more to do with dreaming than of actual relationship. But some girls inevitably acted out their feelings, and this occasioned lectures about 'silliness'. What needed to be addressed, I think, was the important part love plays both in adolescent development and in the seeking of role models. Through my admiration of other girls and women I moved out of the claustrophobic world concentrated on my parents and began to discover myself—my longing to be pretty, clever, athletic, popular. The attraction in some cases was a way of finding the masculine, either my own masculine side, or the masculine that was missing from an all-female society. I cannot see that these early loves were 'silly', nor that they did me any harm, though I might have

found my later relationships to men easier if boys had been part of the yearning of my adolescence. But then no sort of love, in my view, is either silly or wicked.

Under my sister's influence, I had left St Mary's, Kenton, and started going to a more middle-of-the-road Anglican church, St John's, Greenhill in Harrow. When the vicar asked me if I would like to be confirmed, I thought I would, partly because I looked forward to some explanations of the Christian religion at the confirmation classes. I enjoyed them as far as they went, I loved the confirmation service, and I even enjoyed getting up early and going to Holy Communion at 8 am ('early service') as people did then, fainting now and then, because they hadn't had food or drink. Around then the Church of England archbishops decreed that women did not need to wear a headcovering in church. Many continued to do so.

Perhaps the biggest influence on my adolescence was the War, though it was so utterly taken for granted by all of us that in one sense we scarcely noticed it. We lived with few clothes, meagre and boring food (but not so little that we were hungry), virtually no holidays or school expeditions away from home, and a social life almost entirely controlled by whether bombing was going on in our neighbourhood or whether it was a relatively quiet period.

From our London suburb we could see the sky lit with flames night after night, as London itself burned. We spent many nights and days sitting in air-raid shelters—and any plan was liable to be cancelled at the last minute because of 'enemy action'. I remember spending a whole week-end revising for a geography examination only to have it cancelled because of an air-raid. At fourteen that seemed horribly unfair. But we were 'bomb-hardened', used to continual air-raids as the background of our lives, until they became minor inconveniences. It was a considerable lesson in what you can get used to.

In 1944, however, our suburb lay in the path of V1s and V2s. Getting ready for school one morning I was running upstairs when I heard a V1 engine cutting out overhead. In the blast, the wooden trap door fell out of the ceiling and knocked me unconscious, and in the moment or two before passing out I assumed the house had fallen on me. Not very long after this a huge V2 explosion in the neighbourhood blew the doors and windows out, the ceilings down and all the tiles off the roof. For the first time in the War I became

43

seriously frightened. I didn't want to die, but I began to fear I was going to. Life seemed a more precarious business than it had up till then.

My parents arranged a brief holiday in Somerset. It was amazing to live for a bit without air-raids or a sense of danger, and I dreaded the return home. But the long period of hope and anticipation that followed D-Day led us on from day to day, always, it seems to me in recollection, sitting round the radio—one of those big 1930s bakelite radios with a piece of silk brocade stuck over the amplifier. We listened endlessly to the news at that stage of the War, or one of the other staples of wartime listening—*ITMA, Happidrome,* J. B. Priestley's Sunday-night talks, or *Saturday Night Theatre.*

My relation to my parents had somewhat deteriorated. In my early adolescence my father ceased to cuddle me or touch me much at all—inevitably I interpreted this as a loss of love. Now I think it was either that my burgeoning sexuality disturbed him, or that my mother suggested a certain restraint. Unfairly perhaps, I can imagine her saying 'She's getting a big girl now, and I don't think it's a good idea'. What the loss of his hugs and kisses brought on in me was a terrible sense of loneliness, a sense of having lost something important, and a recurring depression. It was typical not just of our family, but probably of most families of the period, that none of these feelings ever surfaced in speech.

There were other complications in my relations with my father. I had been keen to share with him my enthusiasm for ideas, my joy in many of the things I was learning. With pride I showed him an essay about Garibaldi that my history teacher had particularly praised. 'There's no point in my reading it', he said. 'I don't know anything about it. I haven't had an education like you, you know.' I felt as if I had been slapped. What I couldn't let myself recognize was his envy.

There was another problem too. My stammering had always bothered him, and I believe he felt that I could control it if I chose to (this is a common misapprehension about stammering), and that I needed to feel his displeasure. So every year when George VI gave his brave Christmas broadcast, both my parents would wince at every hesitation in order to bring the lesson home to me. At the same time my father would tell anecdotes of customers of his who stammered and how 'painful' it was to listen to.

I had sailed through my early childhood blissfully untroubled by stammering, mostly not even aware I was doing it. I was good at reading aloud, at 'reciting' (an important feature of 1930s education), at acting, at debating, at speaking in class. Probably because of my confidence and aplomb, and my general way with words, I rarely suffered the painful teasing many stammerers endure at school. But at thirteen, partly because of the growing self-consciousness of adolescence, and partly because of my father's 'wounded' look every time I stammered, I became very miserable about stammering and sure that it was 'painful' to everyone in the way my father made out it was to him. Stammering is not an affliction for which the world has much understanding or sympathy in my experience, and for many years it caused me a lot of suffering and loss of confidence which was very largely unnecessary.

Because of the stammer I got sent along to see a child psychiatrist, Dr Saul, who annoyed my mother by telling her that I never stammered with *her*. There was a good reason for this. She was even more of a talker than I was, and I gave up the unequal struggle and rarely said a word. It was difficult in any case. Her questions to me pointed me in the direction of uncovering feelings about my parents and sister that I had no wish to recognize, let alone share with this total stranger, and although I enjoyed going to see her, and, in particular, the potted version of Freudian psychology to which she introduced me, my going there did not change me very much, except for one thing. The IQ tests given to me at the beginning of the sessions established my intelligence as high, and I found this very comforting. Schooling then, and maybe now, seemed always to emphasize what you couldn't do—the clinic was much more reassuring. Dr Saul sent for my mother, who had not accompanied me on earlier visits, and tried to suggest jobs for which I might qualify, far removed, I may say, from the three permitted jobs peddled by girls' schools. My mother was interested in this, and reported it all to me with her usual flair for describing interesting encounters, but it did not alter her fixed plan that I should become a shorthand typist. Both my parents thought shorthand typing was a lovely job to aspire to. My sister had already spoiled their plans for this career by deciding to train as a teacher. When she told them this, their first response was 'Why not become a shorthand typist in the Middlesex

County Council Education Department?' (where a cousin worked). I think they felt there was a sort of hubris in flying too high, and that their daughters' aims should be modest but ladylike, in contrast to the factory and shop work that other relatives had performed.

My relationship to my mother had not improved as I began to grow up, though in many ways I continued to enjoy and admire her. It annoyed her that I enjoyed school work so much, and she had a way of coming into the kitchen in the evenings where I was doing my homework and sighing 'Of course, when I was your age I was out with the boys'. It not only made my struggles with homework seem valueless, but it also made me feel, was meant to make me feel, that no boy found me attractive enough to ask me to go out with him. Which was true, for the very good reason that I knew no boys. In any case 'enemy action' meant that going out in the evening was a rather dangerous undertaking.

But then the War in Europe ended. The extraordinary sense of hope and joy and of life beginning again sustained us for a long time during that interminable period of shortage and greyness that was not to end for another seven or eight years.

In the summer of 1945 I went with some of my class to help with the harvesting in Warwickshire. 'Stooking' barley and wheat and oats, I had my first experience of manual work. Eight hours a day of picking up sheaves was exhausting, even at fifteen, but it was wonderful to be away from the world I was used to, meeting old farm labourers who loved teasing us and flirting with us, and going to the Shakespeare Theatre at Stratford in our spare time.

There is an overriding memory of that working holiday, though, which is that it marked the end of the War; we celebrated with a wonderful supper. But the day before the party I had met a friend in the middle of a field who said 'Have you heard? They've dropped a terrible bomb on Japan and it's ended the war.' Could it be worse than the bombs we dropped on Dresden? I asked. 'Yes, worse. Much worse. The worst bomb ever.'

As horrific as the A-bomb were the pictures of the concentration camps which had already appeared in newspapers and on cinema newsreels. It brought home that, despite air-raids, and the death of school acquaintance in bombed houses, we had been sheltered from the full horror of war. Fed with every sort of propaganda, we were

sealed off from human suffering, even the suffering of our own soldiers. I remember nothing like the coverage of the Falklands War with a young nurse describing her emotions as the first of the wounded young soldiers were brought on to the hospital ship. 'I just wept.'

I don't know whether it was the concentration camps, images of which have troubled me ever since, or merely the process of growing up, but I began to ask more difficult questions about religion, particularly about the existence of God. This seems to me a natural and proper subject for a late adolescent to ask questions about, but when I asked the headmistress, Miss Robinson, during a sixth-form scripture lesson how we could be sure God existed, she replied 'We haven't time to keep going back to first principles!' I felt cheated.

I read C. S. Lewis and enjoyed his rather knock-down school of theology—it gave me a crude understanding of the areas covered by Christian theology that somehow my 'Christian' education had neglected.

A new priest, Joost de Blank, came to be vicar of Greenhill. He seemed very different from any of the clergy I had known up till then. He was of Dutch descent, though educated in England, he was a brilliant and witty preacher, he cared for things I cared for— literature, poetry, art. He also loved things I had been taught to despise—musicals, musical comedy, Hollywood films (the sort with music and dancing), and the less reputable forms of theatre. He was politically aware—the first sermon I ever heard him preach was an attack on South Africa—this was years before everyone with a soapbox attacked South Africa. He had been a chaplain in the Western Desert, and he was still recovering, though I only dimly understood this, from a severe head injury received in a bombing raid.

But what interested me most about him was the sort of passion and energy he brought to religion and the new light he shed on it for me. I complained to him about the sort of religion they forced on us at school, which I perceived by then as about controlling us, keeping us good and timid and obedient. 'Christianity's not about morality', he said. 'That's not it at all. I was brought up in the sort of church where everything was a sin—girls, dancing, playing cards. Now I think that was dangerous nonsense.' And he quoted Augustine: 'Love God and

do what you like.' It was a glimpse, if not of revolution, of a world beyond the stuffy suburban one. I told him of my doubts about whether God existed, expecting a defensive lecture about God's existence. 'Yes, I have those sorts of doubts myself', he said. 'But if I discover on my deathbed that the whole thing is a hoax, I shall still think it's been worth it.' He told me about Pascal's bet, and said 'I've decided to take it'. I was enchanted by his capacity to admit doubt and thought 'That is faith!'

This was all immensely exciting, and under his influence I started reading the books of the Catholic worker-priests which were beginning to come out of Europe. Something was shifting in me—it was terrifying—as if rigid plates that held the terrain of my mind together were sliding and buckling.

My last year at school was not very happy. I was reasonably good at school work, I had friends, there were many things that I enjoyed, but I also felt a sort of pervasive distress that was too diffuse to share with anyone even if I had known whom to share it with. Thinking that Dr Saul might help, I asked to see her, but discovered she had had a heart attack and was recovering in hospital. I don't know if I could have told her what ailed me if we had met. I was overweight, I was suffering periods of depression, I worried a lot about stammering (in what jobs would stammering not be a handicap? I asked myself), and I had a sense of isolation that had nothing to do with how many friends I had.

It was partly that I could not imagine what to do next with myself. The school wanted me to try Oxford entrance and I duly applied. My only knowledge of Oxford was based on Dorothy L. Sayers' *Gaudy Night*, a book that made the place seem both marvellous and formidable. I found it unimaginable. My relatives, uncles and aunts, who had been saying for several years 'What, *still* at school?' as if this was a rather pathetic failure to adapt on my part, were astounded that I might undertake another three years of education. My parents, who really thought it was time to do a shorthand and typing course and get on with being a secretary, seemed puzzled and pained about the whole thing, and I guessed they were also worried, in those days before grants, about the cost. Heroines in the sort of books I liked—Vera Brittain in *Testament of Youth* for example—always got scholarships, but nobody suggested I was likely to get one. What

bothered me most was the thought of another exclusively female educational establishment—I longed to get out into the world, as I thought of it, get to know some boys, and fall in love.

My sister, however, whose guidance I trusted on the whole, thought I should apply, and a teacher foolishly suggested Lady Margaret Hall. I say foolishly because when, having done reasonably well with the papers, I got summoned for an interview, I seemed suddenly to have burst into a different milieu. 'What does your father do?', I heard one girl ask another over the virtually inedible dinner. 'He's a High Court judge.' 'Mine's an admiral.' Apart from having the wrong sort of father, I was also soon aware that I had the wrong clothes. I wore an electric blue dress with embroidery, and brown suede shoes. The others wore neat little tweed suits, and I passionately wished that I could join their camouflage.

The English tutor was extremely nice, and raised interesting points from the papers I had written that made me forget my shyness. The Principal was entirely different. Her first question to me was to ask what my father did, and when I said a shopkeeper, I sensed a faint dismay. She struggled on bravely with the questions for a bit, until I became completely tongue-tied and it was obvious that, willy-nilly, the interview was over. I was not accepted for a place.

I guess the guardian angel in the boat was never more needed, a gentle encouraging angel to tell me to try again, that Oxford or another university would offer more than female company and bad food, that not everyone there was the son or daughter of a High Court judge or an admiral.

Unable to think calmly about what felt to me like a terrible rebuff, I only knew one thing, which was that I could not contemplate spending any longer at school. The sensible thing would have been to have attempted another term's study, there or at home, and taken a sheaf of university papers in the Christmas term. But lacking advice or adult sympathy (what were my teachers thinking of? Not of me, I felt) I flounced out of school, desperate for new scenes and people.

My parents, who must have felt, but were too kind to say, 'We told you so', at once enrolled me in Pitman's Business School in Southampton Row, and with the inner dramatics of Dickens in the blacking factory, I sulked my way there. At least I was free of school.

3

The best thing about Pitman's was that I had nearly an hour in a comfortable train each way, and I used it to read extensively in a slightly random manner. I discovered *The Manchester Guardian* (still with a very distinct Northern flavour in those days, as befitted the title) and *The New Statesman*, in those days under Kingsley Martin's editorship, and I found them much more enjoyable than the (prim) *Spectator* which was given to us in the sixth form at school. (I don't think it ever occurred to me that I would come to write for it.) I read E. H. Carr, who convinced me that Communism was bound to take over Europe. I had the sense to be alarmed by the prospect. I'd like to have found a political cause to give myself to, but Communism didn't feel like the right one. At the same time, I think because of the French worker-priests, and some of the publications of Sheed and Ward (a sparky Catholic publisher), I toyed with the idea of becoming a Catholic, occasionally wandering into Catholic chur-ches, taking pamphlets, and trying to see if I could feel at home there. I couldn't. I loved the art, the philosophy, the courage and subtlety and mystical awareness of the human mind informed by the culture of Catholic Europe, yet there felt to be a hardness, a bigotry, an 'extremeness' there which frightened and repelled me. As with Communism, human suffering always seemed to take second place to theory, as for instance, in the Church's views on divorce or contraception. The reasons for making people so unhappy did not seem good enough. Not that I did not think individuals might find present suffering worthwhile for a cause they cared about. It was more that there seemed too much general enthusiasm for suffering and too much readiness to accept it on behalf of others.

Mind you, the Church of England could be pretty bigoted itself at the time. I remember being astounded by the venom of *The Church*

Times on the occasions that I read it. This did not stop me from applying for a job as a reporter on it. I was interviewed by Rosamund Essex, an ample and hearty woman, I think in her fifties, but dressed in what appeared to be a school gym tunic, who asked me, among other things, whether I knew the difference between a cope and a chasuble. I did not get the job, but was interested to learn, years later, from the owner/editor of the paper, Bernard Palmer, that the candidate who did get the job later became his wife. My loss had been his gain.

Reading, not all about religion, was then, and remained, one of the supreme pleasures for me. I read Thackeray and Dickens, Charlotte Brontë (one of my great literary loves), Bernard Shaw, Cyril Connolly, T. S. Eliot, and Somerset Maugham's *Of Human Bondage*. It was a pity I didn't know at the time that the hero's feelings about his club foot were Maugham's way of talking about his stammer. Also, of course, since I had not begun to understand that homosexual writers of the period felt obliged to translate their experience into heterosexual terms, and did not even know that Maugham was homosexual, I did not realize that Philip's obsessional feelings about the loathsome heroine Mildred were a working out of Maugham's own erotic feelings for a homosexual lover. I knew virtually nothing of homosexuality beyond a vague awareness that some of my teachers had been in love with one another (this had emerged at the school harvest camps) and that some of the senior girls were 'that way'. I read books in a desperate attempt to know more of the world and of life, not realizing how rigidly the books themselves were morally censored. But all the same, reading nourished and comforted me, made me feel that there might be other people in the world who were interested in the things I was interested in. All my pocket money went on paperback novels and books of poetry. It strikes me now as an appallingly lonely time, yet there was an opportunity to think and to read, and it was wonderful not to have homework to do in the evenings.

At Pitman's I was given the task of writing a critique of a new film of H. G. Wells' *The History of Mr Polly*, and it was read aloud and praised to the skies by the English teacher there, Mr Williams. That was about the only bright spot in the interminable wastes of learning shorthand and typing. Only later did I appreciate the pleasure of

being a very accurate and rapid typist—a useful craft for a writer. Shorthand never really appealed to me after the early stages. The faster I got at it the less I could read it. It gave me exactly the sort of panic that Latin translations had given me in examinations at school. There were some nice young women at Pitman's, including a girl I had known at school, and we had fun lunching together or going for the odd drink. The men students were a disappointment, being few and spotty. (I am not really speaking of actual spots, which no one can help, more of a feeling that the men were not appealing to us.)

I applied to the BBC and got sent to their secretarial training school, where I did rather well in the various tests of intelligence, knowledge and skills. To my dismay, the officer in charge remarked to another student about me 'Miss Furlong's terribly bookish, isn't she?' It was plainly true, but none the more welcome for that. I had seen myself as more dashing, and with a bigger appetite for life. How to exercise it was the problem.

I was given a job as a secretary to a talks producer, one of the better jobs the Beeb had to offer. Unfortunately, what I never dared confess at the training school was my absolute terror of the telephone. Sometimes I picked up the receiver and could not manage to get out the word 'hello'; sometimes I could not say whatever needed to be said when the person at the other end picked up the receiver. It seemed useless to try to explain the problem to anyone. I knew in advance that no one would understand, for the very good reason that I never had met anyone who had really understood the depth and complexity of this kind of speech problem. Since no one stammers all the time, it is easy to assume that it is within the stammerer's power to 'stop it'. What most people liked to think was that it could be 'overcome' if only I would make the effort. I think they believed this because the whole thing made them vaguely uncomfortable and they wanted a simplistic solution. There are some disabilities—deafness is another—which evoke less sympathy than irritation in others. I wonder sometimes if it is not that both have a comic element in them, and perhaps feed into sadistic feelings that people would rather not acknowledge. Certainly stammerers learn to expect little understanding.

Miss Robinson, my headmistress at school, had once given me a lecture, telling me not to be so self-centred—'Monica is a very

self-centred girl' she had written on my report after we had had a talk about stammering (thus, for once, arousing my mother's wrath on my behalf. 'You're nothing of the kind', she said, but unfortunately not to Miss Robinson). Others thought they were being helpful in telling me to speak slowly, and were particularly strong in improving stories about people who had crossed Saudi Arabia in a wheelchair. 'Think of Milton, Beethoven, Winston Churchill', Miss Robinson used to say. (Others used to mention Douglas Bader.) People who had never overcome anything in their lives more taxing than a bad cold, had, I noticed, strong feelings about moral courage in others. (It was rumoured that Miss Robinson had a drinking problem.) Of course, I would have liked nothing better than to have 'overcome' my stammer, but I had not the least idea how to set about it, because it made no more sense to me than it did to anyone else. For long periods I could speak freely, but then a name, the need to mention a place or a destination, the necessity to speak in public, or to answer a telephone, left me tongue-tied and sweating with terror. Trying to describe what it was like to a psychoanalyst years later, I felt I hit on the real feeling of it all. 'You know how there are things that people hope will never happen to them in public—like their knickers falling down or their teeth falling out? Stammering made me feel as if those things were happening to me all the time.' 'I had no idea it took so much courage', she said, thus endearing herself to me for ever afterwards. It was a courage not noted by the friends, teachers, taxi-drivers, editors, lovers and people at dinner parties who felt they knew just what the problem was and what the solution. What never seemed to occur to them was that I might be intelligent enough, and concerned enough, to have given the matter a little thought myself.

Anyway, it was a poor basis to begin a job which involved quite a lot of telephoning. I struggled along with it for six months or so, with my speech deteriorating by the day and the hour until I was virtually speechless, and finally, near to breakdown, I resigned. Since I did not want my parents to keep me, I applied for other less interesting jobs. I could no longer face using the telephone—the phobia had become complete.

I took a job with the Fleet Street office of a group of provincial newspapers and almost at once fell mildly in love with a nice man in the office. He was much older than me and unhappily married. I was

unhappy for my own reasons, and felt in tune with his distress. We started going around together—drinking in Chelsea pubs, exploring the East End, which I'd never seen, going to Oxford for the day. It was exactly the sort of male company I had never had, and his love for me helped my damaged self-esteem quite a bit; I chose not to think too much about what it was like for his wife. Another nice thing about John was that he was as 'bookish' as I was, and he understood my longing to write. At last I had someone with whom I could share my literary passion.

After the day at Oxford we managed to miss the last train back to London. We got a bus part of the way home and then found ourselves stranded at, I think, Reading, where we spent the night in the waiting-room. As luck would have it, my parents were away on holiday, and so unaware that I had not come home all night, but John's wife, not surprisingly, was outraged, and informed my employers that John and I had spent the night together. In 1950 this was enough to get me sacked. John's wife later telephoned my mother, who was inexpressibly shocked, and insisted that I must never see John again. I refused to promise such a thing.

The absurdity of it all was that not only had we not spent the night in sexual embrace, but that—child of the period as I was—I was still far too much of a 'good girl' to dream of doing any such thing. I did, however, feel guilty about the idea that I might be stealing John's affection from his wife.

I applied for, and got, another job—with Benn Brothers, a publishing group in Fleet Street, where I worked as a copy typist, mainly typing letters to persuade advertisers to take 'space' in one of their journals, I cannot even remember which one. Since the days when I applied to be an undergraduate at Lady Margaret Hall I had come a long way, it felt, all of it downhill. The work at Benn Bros was mind-numbingly boring—nowadays it would be completed in seconds with a word processor, and a good job too. I was always in trouble for arriving late and for taking too much lunch hour, and I was delighted when I learned of the rebuke Charles Lamb received from his employers. 'You are always the last to arrive, Mr Lamb.' 'Yes, but look how early I go home!'

Fleet Street was an extraordinary place in those days. All the big newspaper houses were still there, in the Street itself, or in the small

turnings off it. But go through one of the little alleyways east of the Street, and you found yourself in a huge field or Moon landscape of bomb rubble and rosebay willowherb which stretched up to Chancery Lane and across to Holborn. The field was full of broken masonry, like upended tombstones. John and I used to meet there at lunchtime, often, in the winter, buying soup from a caravan that parked over towards Chancery Lane.

The other side of Fleet Street was equally futuristic. Much of the Temple was destroyed, but hidden in its nooks and crannies were fountains and seats. It was almost like being in the grounds of a country house. There were also the fascinating deserts of rubble behind Ludgate Hill and around St Paul's. Much of my free time at Benn Bros, and I fear some of the time I was paid to be working, was spent in exploring this broken, but beautiful country, a habit which did not endear me to my employers.

I have always found pleasure and consolation in landscape, particularly perhaps in deserts with their austere beauty. My discovery of real deserts was far in the future, but the post-Blitz desert of the City and Fleet Street, with its beautiful grass and wild flowers, moved and delighted me. It was both a haven—perfect for reading or wandering—and also maybe a metaphor of inner damage and destruction.

In the worst of the BBC days I had decided that I did not believe in God, and that therefore there was no point in going to church; I wrote to Joost and told him about this, though not about my growing sense of despair, nor the mess my life seemed to have got into. He replied sensitively, in a letter that told me he was there if I needed him. He had once quoted Pascal to me: 'Thou wouldst not seek me unless thou had found me', and I suppose, without knowing it, I was in a Pascalian double-bind (an expression which I did not learn until I read R. D. Laing in the 1960s). I could see no compelling reason to believe that God existed, but if God did not exist, I argued to myself, then life was meaningless anyway. I could not, however, manage to go on and make the Pascalian bet—that if God did exist, it would have been better to have believed in Him. It felt to me dishonest. Yet it was this lack of God, and this yearning for Him, that made my life feel disrupted at the very core. Beneath the surface pains of my life

(though now, I see, contributing to them), the mindless job, the stammer, the problems around love, and my mother's fury with me, was this deeper sense of heartbreak and loss. Yet I did not see that I could believe in a God just because I needed one. I went over and over it, trying to see a way through. I am a religious animal, I know now, though I didn't then—religion feels necessary to me, like writing or love, as a taproot of sanity.

I read St Augustine's *Confessions* and envied him the place he had managed to get himself to, though at such sacrifice of himself and others. (I also took a hearty and enduring dislike to St Monica, the matron saint of possessive and emotionally blackmailing mothers.) I read *Elected Silence*, the English edition of Thomas Merton's *Seven Storey Mountain*, and was fascinated, but obscurely frightened by it. If I *did* decide that I was going to be a Christian (in quite a different way I hoped from the milk-and-water-and-decorum system they had inculcated at school), would it mean that I had to become a nun? I couldn't see myself as a nun. I wanted sex, and I wanted children.

I also read Charles Williams' *Descent of the Dove*, a 'history of the Holy Spirit', as he called it, and some of his novels, all of which had been recommended to me by Joost. They were overwritten and often pretentious—Williams was a board-school child who grew up to know many Christian intellectuals, and this beginning gave him a terrible need to show off in print. Nevertheless there was something marvellous and real in his work—a love, a passion, an intense perception of Christianity as the supreme love affair of European culture, a religion later turned into the most powerful container we have seen in the West for art and literature and science. What moved me most was his description of the agony and determination of the Roman Christians ('It is not permitted us to exist') condemned to torture and the wild beasts, dying with the belief that Christ suffered within them. As they used mysteriously to say to one another, 'My Eros is crucified'. This passion of sacrifice, not so much artificially chosen as in Merton's Trappist purgatory, but as a simple response to a situation where truth demanded it, reached me and comforted me in my atheist desert.

Looking back, I am surprised at the lonely way I chose to battle my way through this particular struggle. I am a highly sociable person who, despite the stammer, loves to talk, to argue, to joke, in the

process of trying to make sense of my life and life in general. Even in those days there must have been 'groups', and in any case, Joost had made it quite clear that I could talk to him at any time. I suppose I needed the solitude and the space to make sure that my solution was 'my' solution and nobody else's. I had seen enough of compromised Christianity and didn't like it. Joost, in my few encounters with him, had made me aware of a different possibility, which was a faith that was not about convention, morality, or keeping the lower classes in order, but about a giving of the heart. He had shown me that there might be a way, if I could find it, and that it was up to me to choose it or reject it.

In the end it felt as if it chose me. I sat in the grounds of Lincoln's Inn one bright August day, sad and frightened by life and by myself. Along the way, I had temporarily lost the adventurous spirit of the small girl who had struggled to her feet and marched up the hall carrying a bag of apples. The sun had gone behind a cloud, and behind the greyness there was a dazzling radiance that I felt might have blinded me if I had seen it in full. A huge inner contraction took place, an excruciating bringing to birth, and then I knew myself loved, accepted, accused, forgiven, laughed at, laughed with, touched, held, set free. It was the most important moment since I was born.

For a few weeks I lived with this inner joy—it was a bit like carrying a huge parcel that weighed lightly, a sort of joke package that I could not put down. Then I went and shared it with Joost, who took it calmly, and suggested mildly that now I might like to try coming to church again to 'channel some of the energy'. I did.

There was another, equally extraordinary, experience which followed a few months later. Standing outside Kingsbury station waiting for a bus, I became aware of the whole world as patterned and pulsing with meaning and love. It was beautiful but frightening. I knew that it was always like that, but I also knew that I could not bear to know it all the time. I had to filter it out, as I had once had to filter out the experiences of the child in the garden who had known she was a rose and the rose was her. To filter out such knowledge was both to make life infinitely poorer, but also to make it liveable. Talking to Joost, I began to see organized religion as the container that sheltered us from, but also held us within, the hands of the living God.

At twenty I knew very little about psychology, and so did not in any way try to explain or reduce what had happened to me in terms of, for example, my seeking in God what had been lacking in my relation to my mother. It was enough for me that I felt hugely resolved and comforted, that I could set off again, get on with my life, believe in it, as much as in God. It is only now that I see it as a time in which I confronted madness, which is what the uprush of unconscious material is, and perhaps now I wish a little that I had broken down more completely (with the inevitable risk, of course, of not being able to get myself back together again). This does not make what happened to me 'untrue'—it remains indissolubly genuine in my mind—but I see it now in a different context, the context of many years of sanity. It feels to me that, despite the joy, it frightened me too much. It was like a half-open door with a brilliant light behind it, an extraordinary revelation—and I did not dare push it open because the light itself caused my knees to knock as they once knocked at the sound of the ack-ack guns, it being a terrible thing to fall into the hands of the living God. Alternatively, you might say that the real love and care that my parents did give me, saved, prevented, me from the reckless impulse of going beyond the door. But I made my choice, unconsciously at least. I chose normality, sanity, I underwent a 'conversion' experience and entered the container our culture prescribed for those who 'came back'. I became a Christian.

I had never felt entirely at ease in church services—there seemed to me something a little unnatural in the formal singing style, the being talked and read at, the one-sidedness of the whole performance. Of course, the theatre, which I loved, was equally one-sided (in 1950, that is; it changed a lot later), but that felt all right, perhaps because they tried so much harder to woo the audience. The Church did not woo its audience—it worked on an assumption more like Brecht's alienation principle, though I did not yet know about that.

There were all the things you had to know about in church, which made me acutely embarrassed—when to stand, sit and kneel (being naturally dreamy I was often doing the wrong one), when to genuflect, or fall to your knees (the bit in the creed where it said 'He came down from heaven'), how to say '*Ahb*raham and his seed for ever', instead of '*Ab*raham' in the *Nunc Dimittis*—goodness knows

why; I never found out. Because this was a club I wanted to join I studied the Book of Common Prayer and tried to look like a paid-up Christian. It never occurred to me, at this point, not to become a member of the Church of England.

It did not surprise me in those days that no women ever appeared in the sanctuary, at the lectern or even in the choir—it was simply unimaginable. Asked by the choirmaster whether he might include women in the choir, Joost took the line that they 'would look funny in surplices'. I think now that women's lack of participation in the ritual added to my sense of doubt and unreality about what went on in church, but not so much as the clergy/laity divide. I used to have fantasies of standing up in the middle of sermons and arguing. Not that I disagreed with much that Joost or his curates said—I was still very much at the gulping-down stage, as I had found something I was hungry for—it was just that the teaching method seemed slightly questionable.

In my early churchgoing days at St John's, we had Matins at 11 o'clock, Evensong at 6.30 and Holy Communion at 8 a.m., as was the common pattern at the time, the latter being celebrated with the priest facing east, his back to the congregation. Gradually all was changed—not without frightful ructions of the usual kind—and we had a parish Communion at, I think, 10 a.m. from a table in the nave. I missed Matins, but liked the change all the same. The extraordinary pattern of incarnation traced out in the Mass was what was beginning to speak to me as the central mystery of Christianity.

Joost was a wonderful performer (and I love and admire performers, whether actors, dancers, musicians, priests). He was always punctual, always spotlessly neat and clean, surplice starched, shoes brilliantly polished. Whatever he did he did with style, something I had sorely missed in school Christianity, a religion of tapioca pudding. He brought a sense of occasion to his celebration, and spoke the words so caringly and sensitively, that I can still hear him saying the liturgy in my mind, and feel the sort of reverence out of which he spoke. He was also a wonderful preacher, his text meticulously prepared, argument carefully outlined, and jokes very good indeed.

At parish breakfasts and meetings—and there were many of those as he tried to share with us his vision of what a parish church might

be—he was charismatic, but also a bit of a tyrant. We had to do things his way. Well, we usually wanted to do things in his way, but there wasn't much choice. He was a formidable person. Years later I told him he was a Napoleon (he was a small man), and he laughed, but was also hurt, I think. In certain areas he would not brook argument. I remember a campaign he started to prevent the installation in the parish of slot machines, I think in pubs, in order to sell condoms. He fulminated against this, as encouraging immoral forms of sexuality, but I could not help thinking that if people were going to go to bed together anyway, it might be better to use a condom than conceive a baby. I felt too young and ignorant to take this idea up with him.

I held this belief partly because, with a group of carol-singers, I had paid a visit to a 'mother-and-baby' home in Harrow, full of single mothers waiting to give birth. I knew, because the curate told me, that most of them had been thrown out by parents who could not bear the disgrace, and that most, if not all, of them would have to give their babies up for adoption within a few weeks of birth—'just as they'd had time to get fond of the baby', as he compassionately said. To give birth outside marriage was still a terrible stigma in the 1950s, the prospect of which frightened me a good deal, especially as my mother had somehow inculcated in me the idea that even one indulgence in sexual intercourse was bound to end in pregnancy. Pregnancy apart, the idea of 'having sex' alarmed me quite a bit. It was not that, as in the early conversations with Pat Rose, I could no longer imagine taking my clothes off in front of a man; it was more that I could not now imagine the emotional intimacy involved. Although, in the style of the time, I experimented with several boyfriends in advanced 'petting', I could not quite picture the follow-through, and, to my shame, used Christian belief to excuse me from the emotional level I had still not quite reached. I may have been right to refuse, but I am sorry I used this excuse to hide my fear from myself.

Yet, God knows, I was sexual enough in fantasy. I had enjoyed steamy erotic fantasies as a teenager, lying in the Morrison shelter (an indoor steel framework provided by a thoughtful government to hold up the weight of a house if it fell on you during an air-raid); I used it as a sort of hide-out and day-bed. Then there were, of course,

all sorts of fantasies as a result of my reading. I longed to cross the sexual bridge, yet feared to. And the Church said you should wait for marriage.

Tangled up in the sexual fantasies, as well as in the Christian ideas, was a vision of true love. That there is such a thing as true love, in the sense of a relationship that gives both parties joy and life, I believe to this day. What I did not know in my late teens and early twenties was how rare it was (my parents' marriage, though not without its problems, made at least a comfortable relationship seem very possible). All the excessively idealistic and romantic ideas failed to teach me the basic fact which is that, when love works, it is a mixture of strangely assorted and delicately balanced ingredients—luck, for a start, then sexual and psychological compatibility, then a good strong 'ego strength' or autonomy in both partners, then a capacity for what you might call 'exchange dependency', the ability of both to care and be cared for as the need arises. I had as yet no idea that the vast majority of marriages are collusive or tyrannous, and that a high price is paid in suffering passively or violently endured. That there might be a positive choice for singleness, or that for some people singleness might have more life and fun and go in it than marriage, was not even a thinkable idea in my early twenties. Singleness meant being a drab 'old maid' like so many of my teachers, or it meant being a nun.

Part of what made singleness so unthinkable was the rigidity of ideas about sexuality at the time. If sex must be kept for marriage, and virginity was the supreme gift you had to offer the one special man, then the alternative must be a life without full sexual expression, which for me did not feel like an alternative at all. But even the marriage partner, the one special man, must be selected without prior sexual experience, without any real experiment to find out the sort of person who might make a congenial partner. On some level I knew the whole thing was impossible nonsense, designed by celibates who were locked into their own fantasies, sentimental or envious, of relations between men and women. I wanted love, I wanted sex, and eventually I wanted children, but the sort of thicket I had to enter to get there made me feel daunted. I did not feel beautiful, sexy, confident. Like so many men and women before me, I felt hopelessly shy, uncertain, pushed this and that way by the Church's glib

certainties about right and wrong, my mother's dislike of sex ('Thank God neither your father nor I ever cared much for that sort of thing'), my fear that I might get pregnant, and, last but not least, the strength of my natural desire.

I think it was my lack of self-esteem that led me to the fatal idea that, since I would never find 'the one true love', one man would do almost as well as another. Well, not quite. The year I was 23, two men proposed to me and I accepted the second, partly, it is shameful to say it, because I yearned for change, for something new to happen in my life. Nowadays, I suppose I would go off and work in Europe or Africa or on a kibbutz, and I regret that I did not have the courage to attempt a 1950s equivalent—I have sometimes wished that, like my male contemporaries, I had been conscripted. I think I did not know any other way to leave my mother, who still exerted immense power over me. Then, Bill was a nice man, and we were both terribly lonely. Long before the wedding day I suspected I had made a mistake and I tried to find someone who would help me withdraw, but I was unsuccessful. I consulted the curate, a good buddy of mine. I see now that, locked into a miserable marriage himself, he fancied me, and therefore fell over backwards not to discourage me. He implied that the alternative to marrying this particular man was lifelong celibacy, which I felt to be nonsense even at the time, but I was in no doubt that he thought I should go ahead, as he had himself, with something miles away from what I really wanted.

Nowadays, looking at the courage and determination, the sheer truthfulness, of my children in their relationships, I feel ashamed I did not have more guts, more strength to resist the collective, and I cannot absolve myself at least of weakness and abject folly. In an obscure self-destructive way I think I wanted the relationship not to work, perhaps as a hidden attack on my parents. Or maybe my old 'widow' fantasy was at work.

One good thing about getting married was that it released me, to some degree, from the sense of being an available sexual object, a feeling I had always found degrading, being appraised, like a horse, for one's 'points'. It also meant that I was at last free, by the mores of the time, to explore sexual experience. (What a pity Pat, my old comrade in sexual exploration, was no longer around, but she had married a wheat farmer and gone to live in Alberta. Years later,

however, in our late forties, we met up and caught up on most of the details of our lives. She was as much fun to talk to as she had been at six, or ten, or fourteen.) Bill was a willing and pleasant partner. On our honeymoon in France we spent the morning on the beach, ate a wonderful lunch under the vines out of doors, and then retired for the afternoon to a huge double bed. I loved it. So that was what people went on about.

The 1950s always seemed to me to be an unpleasant and rather disappointing era, full of political darkness and rumours of further wars. The sense of fervour and newness in the late 1940s, the joy of the war being over, should have led, I felt, into a decade of creative exploration, adventure, even lightheartedness. Instead there was the repressive 'girly' fashion of the 'New Look', a forcing of women out of the jobs they had done during the War and back into the home, a huge emphasis on home-making, babies and romantic love.

Apart from wanting children, I resented the tedium and the pettiness of 'running a home', though, like everyone else, I appreciate the comfort and order of a home well run. Cooking was, and is, a great pleasure to me, probably because eating is also a tremendous pleasure, but that apart, I was a poor housewife, and, at this stage of our life at least, although I worked in an office all day, Bill could not quite get over the feeling that the household chores were 'women's work'.

What I did want to do was write. I worked at articles and short stories, and I wrote a novel, which, when the first publisher I sent it to returned it, I put dramatically in the dustbin (just as well, too). It hurt that nothing got published. But then *Punch* accepted an article and paid me £9 for it—to the best of my knowledge it never actually appeared in print. Joost, by now a bishop in Stepney, suggested to me that I should try a weekly magazine called *Truth*. *Truth* had been a famous nineteenth-century magazine, originally dedicated, I believe, to exposing swindles. During the Second World War it had sunk so low that it was run by a Fascist organization and was used as their mouthpiece. But in the early 1950s it was bought up by an owner with very different ideas and it set out to be a magazine comparable to *The Spectator* or *The New Statesman*. Because it had a young staff desperate for recognition it was louder, ruder, funnier than either.

To my rapturous pleasure the editor, George Scott, accepted an

article of mine (about the charm of the suburbs—I have always liked suburbs) and invited me to go and see him. The paper lived in a Dickensian building, now pulled down, in Carteret Street, near St James's Park Tube station. I can see the entrance hall with its huge mahogany desk, the dark stairs, the little secretary's room upstairs, and George Scott's big office, so clearly that it is strange they no longer physically exist. The door was opened and a cup of tea was brought to me by a friendly and very willing office boy. Or so I thought. Actually, it was Bernard Levin, the assistant editor, looking ridiculously young. It was the beginning of a long friendship.

I began to write for *Truth* on a regular basis, and the high spot of my week was going in to see the staff to take them my 'piece'. There were a nervous few moments while George read it, and did or didn't like it, but there was the fun of all the conversation, the ideas, the general rudeness and subversiveness about everything. I felt I had found a home from home.

Gradually too, I was beginning to write for other papers. It was a precarious income, but enough to make it possible to give up the crushing boredom of paid office work.

Another good thing happened around then. I saw an advertisement for a research programme on stammering at St Mary's Hospital in Paddington and offered myself as a guinea-pig. The two women speech therapists who ran the programme were, they explained to me, working with two major ideas. One had to do with an odd discovery that if stammerers could not hear themselves they did not stammer, presumably because the kind of 'monitoring' of speech that everyone does as they listen to themselves speak is linked, in the stammerer's case, with a sense of difficulty and failure. So far as I know this discovery never led anywhere, mainly because stammerers cannot conduct a conversation while deafened by headphones, and the technique does not lead to the sort of re-education of speech the inventor must have hoped for. The other line of research had to do with what is called 'voluntary stammering', a technique of encouraging people who have spent their lives in an agonizing struggle not to stammer, to stammer deliberately to break the pattern of avoidance. This can give a sense of control, something a stammerer lacks. I was not to find that it made all that much difference to me so far as stammering was concerned, but it made all the difference to my

attitude to it. That, instead of being the shameful thing my father had led me to believe, it might be played as a game! Better even than this was the joy of at last meeting people who understood the pain of stammering. 'The stammer may not sound much to you', I said at my first interview with them, 'but I find it makes life very difficult.' 'Believe me, we know enough about it to know just how much pain is involved', one of them said, and at once I felt I could trust them. Their kindness, sympathy, laughter, made an extraordinary difference to me. I began to feel better about life.

In the middle of the programme I became pregnant and I was delighted. 'Oh, you poor darling!' was my mother's response, and she promptly burst into tears. Feeling rather foolish, I insisted that I really did want a baby. It is true I had secret fears and fantasies about it, though, as was so usual in my early life, I shared them with nobody. Not much is ever said about the strange experience of having one's body change its shape, of the kind of threat this is to a steady identity. I had fantasies that what lay within my womb was not a baby but a huge growth of some kind—even the delight of feeling my baby stir and kick at four months did not wholly dispel this idea, as if the fear flourished on quite a different level from fact or reason. I had fears too, like so many mothers, that the baby would be damaged, disabled, as if I could not believe that I deserved a perfect baby. But perhaps both the fantasy and the fear stemmed from the fact that conception and birth is such a miracle that it is almost impossible to take it in.

My antenatal care took place at Queen Charlotte's Hospital at Hammersmith, where I was to have the baby. Antenatal visits were an extraordinary exercise in being put in one's female place, i.e. under a male thumb. We would be given an appointment, say at 2.30, arrive, undress, put on a skimpy dressing-gown that in no way covered our bulk, and left to sit on an uncomfortable bench in a cold corridor for an hour. Talking to each other we would discover that perhaps 50 of us had been given a 2.30 appointment. A quarter or half an hour later than the collective appointment time, the consultant would return from lunch and the slow process of being 'seen', i.e. having a student lay icy hands on one's bare belly, would begin. 'Why don't you stagger the times you tell us to come?' I was once rebellious enough to ask the Sister. 'In case the consultant should be

kept waiting', she replied. *Quod erat demonstrandum.* Better that 50 women, whatever their other responsibilities, should be kept waiting for an hour than that there should be a remote risk of keeping the consultant waiting for even a minute.

I had one very frightening experience in that antenatal clinic, for which I have never forgiven Queen Charlotte's. I arrived for my examination as usual, lay down on the hard bed, and waited for the icy-handed medical student. Instead the consultant himself came in and, without even saying 'Good afternoon', began to manipulate the baby from the outside, grabbing handfuls of my belly and pushing and pulling them in a way I found absolutely incomprehensible as well as very painful. Frightened for myself, my major instinct was still to protect the baby. It occurred to me that he might simply have gone mad. Terrified, I pushed his hands away and asked what was going on. 'Oh, for God's sake, keep quiet', he said and continued to manipulate me. Fortunately the Sister came into the cubicle at that moment and said 'Try to relax', which did at least reassure me that the exercise did have some medical purpose. Baffled, I let him get on with it.

After a few minutes he appeared satisfied, and disappeared as wordlessly as he had come. Sick and trembling so much I could hardly stand I asked the Sister 'What was that?' 'He was turning the baby', she said. 'It was upside-down and he turned it so that you will not have to have a breech birth.' 'But why didn't he tell me?' I asked, and she had no reply. As it happened I had not even heard at that time that babies could settle in the womb with feet, instead of head, pointing downwards, and if the consultant had had the politeness and the common sense to tell me, I would have been delighted to co-operate in a minor operation that was clearly for my own and my baby's good. As it was it became something that felt like a sexual assault.

'Why not write to Queen Charlotte's and complain?' my husband said indignantly that night. Of course I longed to complain, but I understood very little of the internal workings of the hospital, and feared that when the birth came I would be marked down as a troublemaker and worse would follow. (I think this was a hangover from the punitive methods of my school days, but nevertheless a woman giving birth is horribly vulnerable, and Queen Charlotte's had not got to the stage of allowing husbands to be present.)

As it happened, Dr Grantly Dick-Read was in London around then and *Truth* sent me to interview him. As a result of talking to him and reading about his ideas, I joined a relaxation class and got the idea that birth, properly handled, need not be excruciatingly painful. I tried to practise the relaxation, but knew myself and my reactions to pain too well to feel confident that I would manage deep relaxation when the going got difficult.

I didn't. I was left alone for hours in a side ward until the pains were really severe, then taken to the labour ward, where I was ignored until it was discovered I was actually beginning to give birth. Then I was put on to a trolley, taken down a corridor, put in a lift, taken to the delivery room ('Don't push, don't push', they shouted at me all the way) where the houseman sat in a corner and read *The Evening Standard* throughout the birth. I completed the drama under the gaze of a huge clock, whose face is etched on my mind forever. The pain was intense, but at least in the delivery room I had the midwife's attention. When my daughter was born—at ten to 2 in the morning, as I knew from the giant clock—I was able to take her in my arms and welcome her joyfully. There is a moment just after birth, it seems to me, when a baby looks truly herself—if you have eyes to look, then you recognize the person who has been invisibly in your life for nine months more clearly than you know a stranger who has just come into the room. I knew Charlotte, and knew that we would love one another. (I didn't name her after the odious hospital, by the way, though the Matron preened herself when she discovered her name. At St John's, Greenhill, there had been a nice old lady in her nineties with the pleasing Victorian name of Charlotte Ann Hill, and I named my Charlotte, Charlotte Ann, in memory of her.)

Just as I had had no idea in advance what horribly hard work it would be being a housewife, so I had little idea of the sheer hard work involved in having a baby. The bathing, the changing, the nappy-washing (disposable nappies had not yet been invented), the endless feeding, seemed like a life sentence. 'This will go on for another fifteen years', I remember reflecting gloomily at 6 o'clock one morning as I gave the feed. The disruption of my life seemed to be total.

Yet it was paradoxically full of delights. The moment when Charlotte smiled, put on weight, slept through the night for the first

time, cut a tooth, sat up, began to make talking noises, were all part of that extraordinary reciprocity that takes place between a mother and baby, the continual exchange of attention and emotion. Bill, too, was a caring father, as delighted with this little scrap of humanity as I was. We thought and talked of little else.

The baby apart, the best bits of my life had begun to take place away from Bill, in work, and with friends I was beginning to make, who were somehow nearer to the person I felt myself to be. I was guilty about this, but whenever I tried to share them with him it never worked. Bill, not surprisingly, felt angry in the awareness that so much that was important to me took place away from him, and I had no idea what to do about it. I could not bring myself even to look at the idea of separation or divorce, but the relationship felt wrong. Not totally wrong—there was a level on which there was a deep closeness between us—but it was deeply frustrating. At times I felt eaten away by the misery of it, and could not stop myself looking out for other men who I felt might make more likely partners. It was impossible.

Like so many couples caught up in denial of the need to part, we had another baby, Alexander, a wonderful roaring boy, big and strong, with a huge appetite and a great zest for life. With two children whom I loved deeply, it was easier to lose sight of a basic dissatisfaction, to take my pleasure from their growth and joys and achievement.

4

I see myself as a young adult, married, with two children, trying like someone lost in a thicket to find my way through the various fantasies, collective and individual, that I had picked up from my reading, or had had spread before me by others, a banquet of ideas. Religion gave a unifying sense to these fantasies, though it was also, of course, part of them. The occasion on the seat in Lincoln's Inn Fields had linked me, indissolubly I know now, to the central myth of the West, the myth of God the Father and His Son Jesus. At this point God the Father felt like the healing influence, maybe because my relationship to my human father had been so good, yet I knew that even if Alfred Furlong was a sort of window into the unimaginable being of God, I had got swept past that relationship to a place beyond the boundaries of my relationships or experience.

The words I had for that experience were 'wonder' and 'praise'. I groped my way around inside that myth, trying to make sense of 'Church', still unaware of all the complex reasons, hopes and despairs that bring people to that place, as my own complex reasons, hopes and despairs had brought me. I think I was lucky in that quite soon I found congenial friends who were themselves groping in the same area—a group who produced *Prism*—Christopher Martin, Nicholas Mosley, Donald Allchin, Valerie Pitt, Tim Beaumont, Humphrey Green. Talking to them, I knew both how ignorant I was, and also how much I understood. Various members of that group were important to me for a good many years after that.

I began to write about religion for *The Spectator*—rather alarmingly propagandist I was, it seems to me now. What basic insecurity is it about Christianity that so often makes us such naggers about it?

Privately, I was struggling with Christian 'exercises', supposing that this was what my religion required of me. I went to confession, for

instance, but quickly found that for me, at least, it had a sort of law of diminishing returns. At the beginning it gave a useful perspective, but as time went on, and the sins were invariably the same, it began to seem a bit pointless. I was not concerned so much with absolution (I have never felt I was a great sinner, finding that a rather self-important idea) as in not doing things I regretted or believed to be wrong in the first place. It was becoming clear to me that change needed to take place at a much deeper level, at the level of understanding why I did what I did, and none of my confessors knew how to address that. Also, I was gradually coming to see that it was not necessarily sins in the formal way the Church understood them that were an offence against love (though sometimes they were, of course). It was rather sides of myself I did not know at all, things I took absolutely for granted, that damaged others. Only by catching a glimpse of the hidden side, rather like seeing one's own back-view, could I really be different. I had no idea how to do this.

I also experimented with exercises such as fasting. Like confession, I found it useful in the short term, because it taught me something I did not know clearly before—that we are almost helplessly dependent on our appetites. Withdraw food and we may find ourselves thinking of nothing else. A friend who was a starving inmate in a German prison-camp once told me that the prisoners talked of nothing but food, except at the rare intervals when Red Cross parcels arrived and they got some square meals. 'Then we talked about women. When the parcels were finished we talked about food again.'

I see the point of becoming aware of the appetites—it is part of the religious process of recognizing dependence, which in our arrogance we are apt to forget. I see the point of a reasonable control of them. I also see the point of doing what many have done in the past and using the absence of food to induce useful psychological states—'fasting to a vision'. Yet if, as so easily happens, the whole exercise slips into a contempt for the body and its simple, honest appetites ('Brother Ass', as St Francis so oddly saw the body), then dualism has taken over, with the higher mind feeling superior to the lower body. It soon appeared to me that the only good thing that could come out of fasting was to fail. If you failed you recognized the primacy of the appetites, knew yourself humbly and simply for the animal that you were. If you succeeded, how could you fail to feel

pride as you triumphed over poor 'Brother Ass'?—a thoroughly un-Christian attitude!

This is where I got to with fasting in my thirties. Nowadays I am still not sure. All the studies of anorexia done since the 1960s show the primary importance of food in everyone's life—it carries more emotion for those who despise it than for those who straightforwardly love it—and it is a key which cannot be left out of people's spiritual development. The only uncontaminated versions of fasting still remaining to us seem to be of two kinds. There are the twenty-four-hour fasts undertaken as an act of solidarity with the world's hunger—provided we do not imagine thereby that we have actually made any difference to the problem of the hungry; the exercise is entirely for the benefit of our own imagination. The other sort of fasting exercise which I regard as possible is fasting to a vision. Visions are not much prized nowadays. I wonder if we shall find we need them.

The 'churchmanship', as we used to say then, of the *Prism* group was largely Anglo-Catholic. Nick Mosley, perhaps the most influential of the group so far as I was concerned, had become a Christian through the influence of Mirfield and Fr Raymond Raynes. I was attracted to the aesthetic qualities of Anglo-Catholicism, not simply in liturgy (which, in truth, I found a bit protracted as in those interminable Sundays at St Mary's when I was a child), but in the general capacity to turn to art, literature and ideas, an aesthetic and, I suppose, rather sophisticated enjoyment of life. But there was also something (not in that particular group, but in some who were near to it) mannered, willed, slightly arch and self-conscious which I recognize cringingly now as I read Barbara Pym, or listen to certain Anglo-Catholic friends chattering and gossiping, with the kind of 'in' jokes, often somehow related to homosexuality, that make me feel an interloper. Nowadays the sight of a man dressed in one of those black cassocks with umpteen little buttons down the front, or worse, in elaborate cloak and biretta, produces instant prejudice in me. I see that a few women priests are already copying them.

I could not begin to put this sort of unease into words, or even thoughts, in those early days. I was still too much in love with all things Christian. By 1964, though, when I wrote *With Love to the Church* I was beginning to try to express some of my uncertainties.

Early in 1963 I had met John and Ruth Robinson and discussed with them some of the ideas soon to appear in *Honest to God*. I loved John's lack of affectation, his readiness to struggle with theological ideas, and to do what so many of his later critics could not forgive him for, which was to share those ideas with the supposedly 'simple faithful'. But it was Ruth who really challenged me. I said that I had 'experienced God', that it had been more than something 'inside me', or in the ground of my being, and Ruth said 'But perhaps it was simply that you needed to experience that'. Now I am more aware of the complexities of thinking about God outside and God inside (though I am not sure that this is not a fairly meaningless division), but at the time I felt that I must examine whether I had been practising a form of self-deception. This was the real Christian exercise of my thirties, the examination of the origin and depth of my faith.

There were other fantasies and myths active in my life just then, for instance, being a writer. Arranging words in my head is for me an intoxicating experience, one of the greatest pleasures I know; it both feels to be an unselfish and unselfconscious process, yet simultaneously feeds into my need to be a performer, to try to excite interest and admiration. In my best moments I get from it a dimly perceived pattern or tune, in which, mostly unselfconsciously, I am moving in a sort of contemplative dance. But before the contemplative dance is something more alarming, which I resist, as all writers resist it, and which only the great ones can really handle. I think of it as a sort of bungee jump—a willingness to give oneself to a frightening fall into space. Because 'the jump' scares me a lot, my writing is more limited than it might have been, and such guilt as I suffer from (not much) is around this particular responsibility: 'I ought to be bungee jumping today and I'm not. I'm too chicken.' But it has made it difficult to consider working seriously at anything else.

The other thing in my life that has felt like this inner bungee jumping is giving birth, which, whatever the ameliorations of modern science, is still a very costly human experience, a giving of oneself up without reserve to a process you don't understand at all. It costs, as Blake said of experience, 'no less than everything', and the reward is the astonishing one of bringing new life into the world. I have never been more frightened than in giving birth to my children, nor more glad.

I wish now that I had understood more of the myths around motherhood and womanhood (it was more like Motherhood and Womanhood at the time), with all kinds of hidden agenda about women's duty to sacrifice themselves. There is sacrifice enough in pregnancy and birth, and the huge burden a young baby imposes upon its parents for years after that, without women being enjoined to give up other things, particularly other forms of work, which make life precious to them. It is not enough to say the children need them. Both the children's needs and the mother's have to be taken into account if the children are not to suffer from their mother's frustration and resentment. In fact now I think it is very important for mothers to find ways of maintaining their own separate identities from their babies.

Probably because I had experienced my mother as not really being there for me, I had high ideals about my own emotional response to my children, and huge unease when I felt a need for much else beside them. I imagined that if I wanted to work as well as have children it meant that I must toil ceaselessly to keep husband and children as little aware of this as possible, which, of course, meant that they often had to put up with me ragged with exhaustion and no good for anything. Talking with my daughter and daughter-in-law nowadays, I am aware of their very different visions for making their families work. Thank God.

Woven through many of my struggles was the fantasy of True Love, of the one person who would fulfil all sexual and emotional needs, and with whom, like Darby and Joan (whoever they were), or for that matter, my parents and grandparents, one would totter on into old age.

The trouble with the sort of reach-me-down fantasies that get peddled in our world is that they are neither quite true nor quite false. All have seeds of truth within them if they are pursued with unselfconsciousness, or the sort of wholesome selfishness that the ethos of the time did not encourage. But like all falsity in our lives, with time they gradually come unglued, only the true bits remaining properly in place.

My personal ungluing (and that of innumerable other women, of course), though this was still in the future, took the form of discovering that marriage did not lead me to True Love, or even to a

warm and compatible relationship, despite a popular song of the period that asserted that love and marriage went together like a horse and carriage, and that one was unthinkable without the other. Human history shows that fact has a way of being more variable than ideology. As it was, I used propriety, and in particular Christian propriety, to keep the falsity precariously in place.

One of the important moments of the 1960s was for me the passing of the Homosexual Law Reform Act in 1967. As a Fleet Street feature writer who wrote about such things, by then I had listened extensively to the homosexual organizations that were then bravely coming into being, and particularly to Antony Grey, the secretary of the Homosexual Law Reform Society. What had always shocked me was the blackmail, the use of police provocateurs, the frequent imprisonment of gay people, and the routine disgracing and humiliation of the nice and good that the existing law encouraged. I was ashamed, as I am to this day, at Christian involvement in this long story of persecution and human distress. What the passing of the Act showed me, partly because of my own tiny part in the campaign, was that it is possible to change things, a lesson which always seems hard to learn in Britain.

I was particularly concerned because of my very gradual discovery (we did not speak of these things in the 1950s) that the people I loved dearly who turned out to be homosexual had suffered badly partly because of the law, but also because of the mercilessness, the lack of imaginative sympathy that underlay it. Foremost among homosexuals I cared about was Joost de Blank.

Joost, who had been Archbishop of Cape Town for seven years, had a stroke and came back to live in England. At once we took up our acquaintance again. I had grown up a lot since our early friendship. Joost had suffered in the South African situation, confronted both by personal difficulties and by a job which, in the era of the Sharpeville massacre, no amount of hard work or efficiency could make easy. I think he felt himself defeated.

For the first time since we had known one another, over lunch one day Joost spoke of what it had meant to him in his life to be a homosexual. Like so many he had felt the difference since childhood, and felt frightened and ashamed. Under the almost hypnotic

influence of the Oxford Group, when he was an undergraduate at Cambridge, he had felt obliged to write to his parents telling them the problem he felt he had—he had not actually acted upon his feelings—and their Dutch Reformed understanding had left them horribly shocked. They could never, ever bring themselves to discuss the subject with him. As a young curate he had turned to psychotherapy, desperate for a cure, but in vain.

In the Army, as General Secretary of SCM, and again when he came to Greenhill, he had tried to suppress his feelings, as the Church taught him to do. He had succeeded after a fashion, but at the price of a bitter loneliness, and, at times, a tendency to drink more than was good for him. 'I remember one night at the Xs' [a fashionable couple in Greenhill] I had had too much to drink and I blurted out more than I should, and there was a terrible silence, and then somebody changed the subject.'

Finally, in South Africa, the unlived life caught up with him, and he fell deeply in love. I cannot be sure, of course, but it seemed to me that the stroke came out of the destructiveness of this late love, which was not only too late in his life, but a bad choice. 'Now I wish I had not fought against it at Cambridge. The opportunities were all there, and I did not take them.'

My deep love for Joost made it possible for me to guess something of the pain this good, loving man had endured silently for years, as well as to wonder why on earth such suffering was necessary. Might he not have led a happier, healthier, more fulfilled life if he had taken the opportunities for love that Cambridge offered? Why should he go through life lonely and ashamed for something which harmed no one, and which in its essence was beyond his control? And what sort of a Christian community was it which condemned him to this silence?

Much changed in Britain as a result of the Act, but the Church is as fearful as ever, denying that it ordains homosexual men or women, while continuing to do so, either by forcing them to lie, or by knowingly turning a blind eye. If the bigots had their way, a man like Joost could not become a priest, whereas he was simply the best priest I ever knew, one whose life had incalculable consequences for good in my own life.

There is hope, however, and it takes the form of a growing

contempt for inhuman beliefs of all kinds within all the churches. Among my Anglican priest friends, I count a number of gay men who live openly with a partner, and others, single, who would not dream of keeping up the sort of pretence Joost felt obliged to sustain. It takes courage, the sort of courage that the closet gays find so hard to assume, but integrity always takes courage; It is the only real path to love and freedom.

I made a small step in the direction of my own integrity around then. I had never felt able to discuss my marriage with any of my friends—it felt disloyal. One day I lunched with Donald Allchin, and was surprised to find the whole story of my despair suddenly poured out and received by him in a way for which I shall always be grateful. He simply understood.

My thinking about religion was beginning to change somewhat. Part of it was Nick's influence. Because of Nick I started to read Jung. I have a vivid memory of reading *The Answer to Job* on a Spanish seafront, and struggling with Jung's idea of God as identical with the unconscious.

Reading a Cambridge collection of essays—*Soundings*—I was very excited by Harry Williams' essay which explored religion through the perspective of depth psychology. (I read it in the train and was so fascinated by it that I passed my stop.) Behaving like a fan, I asked Harry if I might go and see him—he was Dean of Trinity, Cambridge at the time—and with great courtesy he invited me to a wonderful lunch. I knew that I would love him, and I did. He was, and is, a wonderful man to talk and laugh with, with all sorts of bits of wisdom thrown in by the way.

My response to these ideas was not really a theological one. Partly I felt a need for much more psychological understanding, and, like so many in their mid-thirties—the beginning of 'the second half of life', according to Jung—I went through a sort of love affair with Jungian ideas. I was also becoming deeply fascinated with Zen Buddhism, and worked hard at what I hoped was Zen meditation. Quite quickly I was to come up against a problem in meditation that bothers me to this day, which is how to form a regular practice without some sense of self-improvement, and therefore of self-congratulation, thus strengthening rather than weakening the illusory sense of the self. I remember a conversation I overhead once in

a restaurant in California: 'How long do you spend in meditation?' 'About a quarter of an hour.' 'That's not enough. I do at least 40 minutes.' So it's a competition?

This fascinating conversation went on to 'How many times have you experienced *satori*?'

Some of my longing for silence and quiet was a reaction to the impossible busyness of my life—trying to reconcile working life with the needs of a family. Some of it was a need to understand myself, my fears, my failures better.

The psychiatrist and analyst R. D. Laing, one of the prophets of the 1960s, with his radical books about schizophrenia, said that modern Westerners 'repressed transcendence', rather as nineteenth-century people repressed ideas of sexuality. It was this inhibition, he thought, that made us despise visions and the mystical world. Like so many in Britain and America he experimented with LSD and found there the visionary world he felt was lost.

Several years before, Aldous Huxley swallowed four-tenths of a gramme of mescalin dissolved in half a glass of water and sat down to wait for results. He found his attention sharply focused on a flower arrangement of a rose, a carnation and an iris, which had interested him only briefly on the breakfast table. 'I was not looking now at an unusual flower arrangement. I was seeing what Adam had seen on the morning of his creation—the miracle, moment by moment, of naked existence.' Taking LSD in his garden, Alan Watts saw that

> ... the trees, shrubs and flowers seemed to be living jewelry, inwardly luminous like intricate structures of jade, alabaster or coral, and yet breathing and flowering with the same life that was in me. Every plant became a sort of musical utterance, a play of variations on a theme repeated from the main branches, through the stalks and twigs, to the leaves, the veins in the leaves, and to the fine capillary network between the veins. Each new bursting of growth from the centre repeated or amplified the basic design with increasing complexity and delight, finally exulting in a flower.

Not everyone found a visionary world in LSD. The religious writer R. C. Zaehner described a pitiful and awful experience he had had under LSD. He had sat under the rose window of a chapel in Oxford,

and had seen its perfect roundness become horribly distorted and ominous. As time went on, of course, far worse things happened to many people than happened to Zaehner. An Oxford undergraduate told me how he wandered the streets trying to get passers-by to sing a tune with him and was picked up by the police to be confined in a cell overnight, in a state by then of acute paranoia. Others had LSD put in drinks at parties and drank it unknowingly, believing they had simply gone mad, and among the young there were many breakdowns. In the mid-1960s the full danger of the drug being available on the street, and thus being taken unsupervised and often by people in unstable states, had not been realized.

I had watched the public debate about LSD with the greatest interest, being particularly interested in how threatened Christians felt at any suggestion that mystical or visionary experience might be had by taking a drug. As Huxley had pointed out, we are chemical creatures whose feelings are affected by chemical changes whether induced by alcohol, sexual desire, meditation, fasting, heat and cold, or dancing. I asked Laing if I might interview him for a newspaper article. We lunched together, and I asked him my carefully prepared question, derived from a study of *The Divided Self* and other books he had written: 'What is the difference between the visionary experience of the saint, the experience of the schizophrenic, and the experience of the person taking LSD?', I asked. 'If you are holy you have a holy experience', replied Laing. 'If you are sick you have a sick experience.' There was a pause and he said 'Why don't you take LSD and find out for yourself?'

I have written in another book (*Travelling In*, 1970) of taking LSD, and for my pains the book was banned in Church of Scotland bookshops! I still remember LSD with gratitude. The Fleet Street years had obscured the white-hot religious passion of my twenties—necessarily so, perhaps. But the drug, so comprehensively despised by religious people, recalled me swiftly and powerfully to my Christian orientation and led me to an insight which astonished me. Its first effect was laughter—laughter at my own seriousness and folly—laughter essentially at the lack of perspective which attends the human condition. Then, just as Huxley had been moved to the roots of his being by a flower arrangement he had scarcely remarked before, so I became transfixed by the wonder of the sun glittering on

the neck of a bottle of whisky. This vision, for it was no less, alternated with the astonishing beauty of the grain in the table.

My mind began to fill with paintings I knew well, all suddenly alive, and with a vivid sense of historical periods, but this alternated with a desolating sense of pain and evil, as if I was walking through Auschwitz, devastated by what I saw. Gradually, perhaps because of some Beethoven that Laing played, I moved into a deep, indeed overwhelming, awareness of the Crucifixion. I, who had felt I had a sort of blind spot so far as Jesus was concerned, suddenly felt that, like some who experience stigmata, I was hanging on the Cross with Jesus, with blood and sweat running down my face. 'Christ is us!', I exclaimed, as I began to understand that the Jew dying in the concentration camp, the child dying of hunger, is Christ, as Jesus of Nazareth was Christ. We all partake of it. It is this that makes Christ the Way, the Truth and the Life. In imitating our life and our suffering, Jesus becomes the Son of Man, the Christ, the 'archetype of the self' as Jung calls him. It is this Imitation of Man that makes the Divine within us manifest, explicit, and can lead us through our suffering to resurrection.

The experience moved on to a strange experience of good and evil which I believe expressed something of my own splitness at the time, my own difficulty in living on the broad base of self-forgiveness, instead of the narrow and precarious one of self-dislike. *That* I was not yet ready to deal with.

LSD had another effect on me, as it did on many others, which was that it made worldly considerations like having a job seem unimportant. I was tired after ten years of coping simultaneously with a job and a family. I wanted a quieter existence, and I wanted to write more books.

Bill was enthusiastic when I suggested moving to Norfolk, a part of England I had loved since I was a child. I gave up my job and we bought a nice old Victorian house with three-quarters of an acre of land in a village. For the first time in my life I developed a passion for gardening (one which has stayed with me). Bill, who had always been a gifted gardener, grew the best vegetables I have ever tasted.

Townie that I am, I was amazed by the pleasure I got from the country—the windswept sunsets which lit the flat fields, the evening mists and fogs, the vivid colours of the marshes, the huge seascapes

and the vast sandy beaches. I also enjoyed my conversations with local people. We had been warned beforehand of the unfriendliness of Norfolk people, of the Anglo-Saxon feel of the place that was said to exclude foreigners. It was not our experience. Provided we showed a proper humility as incomers, we felt accepted—not as local people, we could never be that—but as acceptable inhabitants to be teased and gossiped about, but also to receive a lot of kindness. I was fascinated by the rootedness of families who had lived in and around the same villages for generations. The plumber told me once how he had 93 cousins and aunties in the half dozen villages that surrounded ours.

Several years before I left London, Joost had had a more serious stroke that disabled him badly. I went to see him in hospital and found him suddenly an old man, white-faced and white-haired. Later, he unwillingly took part in a wearisome rehabilitation programme. Never a man to enjoy exercise, he bitterly resented the whole process: 'I ache in every bone in my body', he said. He was deeply sad, weeping when we met. 'People say to me that now I can pray', he said, 'now I can no longer do anything else. But I can't. I am not sure I believe in anything any more.'

A few months later he died, and I have missed him sorely ever since.

Another painful event from around that period was the suicide of a friend of mine. She had had a broken love affair and had made an earlier suicide attempt. I had gone to see her in hospital then, but because of the general stress of my life had not bothered too much about her after she got back to normal. Just before Christmas I had arranged to see her, but the hurly-burly of the office Christmas party and preparing for a family Christmas caused me to cancel it, and I scarcely noticed she had stopped telephoning me. Soon after Christmas she killed herself with an overdose. Of course, it wasn't my fault any more that it was the fault of any of her other friends or her lover. Yet, getting happily on with my own life I had blocked out her continuing distress, wanting to believe she was all right again and that all would be well.

A kind of counter to that sort of helpless loss is a visit I paid to Jerusalem and Galilee to write a piece about Easter for a newspaper. I had heard so much of how spoiled and commercialized the Holy

Sepulchre and the other holy places were, that I went with the lowest expectations, and so was entirely unprepared for how moved I should be. The amazing sight of that shining city from the Mount of Olives, the noisy power of the Sepulchre with so many liturgies echoing within it, the simplicity of the *Via Dolorosa*, the beauty of the mosques and the Western Wall, the wonderful Church of the Nativity at Bethlehem, all delighted me. Jerusalem, and Galilee even more so, seemed full of a presence that has stayed with me ever since.

5

Life in the country gave me more time to assess my life up to date. I thought a lot about the age of 35 being the beginning of the second half of my life; after the huge output of energy in caring for children and working as a journalist, I had a longing for inwardness and a hunger for what had originally driven me towards religion. Increasingly I was seeing psychology as a language that talked about many of the same things as religion, and I tried to translate my thoughts back and forth between the two languages as a way of testing them, by seeing what one language said about the other.

At the same time I had discovered Zen—though strictly speaking it was the speech therapist at St Mary's who had started the discovery a decade before, pointing me to Eugene Herrigel's *Zen in ·the Art of Archery* as a helpful way to think about stammering (which it was). I read about Zen painting, and continued to attempt Zen meditation. I began to read Zen stories and was fascinated to discover that many of them were identical with 'Desert Father' stories. For example: the cave or hut of the holy man is raided by thieves in his absence. The old man comes back just in time to see the thieves disappearing into the distance, and snatching up the one possession they have left behind, he runs after them shouting 'You have forgotten this!'

Churchgoing in Norfolk was not easy. Our rector was a man with a mania—a hatred of Roman Catholics. The back of the church was filled with pamphlets about the Inquisition, and on Orange Day he could be seen on television in Belfast marching to the drum and fife. He had a peculiar quirk about hymn-singing: he installed a tape of thousands singing in the Albert Hall, and from across the fields on a Sunday morning you might have supposed the whole of Norfolk had come to join us. But he preferred those actually in the body of the

congregation not to join in. In fact, he fell out so completely about this with one of his churchwardens that the warden refused to go to the church any more; then everybody stopped going to church. Such was the need for the village centre which had once been the church that the village built its own village hall instead, and that became the centre.

Sometimes on Sundays I made the journey into Norwich to the Cathedral. Alan Webster was Dean at the time. The services were superb, and I never regretted the effort. Over a glass of sherry after the service I met Margaret Webster for the first time—unknown to us it was the first step in what became an important partnership.

My life was less busy in the country, as I had hoped it would be. I had more time with my children, time to work in the garden, to walk, to think, to write. I had often thought of studying philosophy, and I began working for a degree.

The time to think had its own problems, however. Ever since I had got married nearly 20 years before, I had chafed and grieved over my marriage. I don't feel free to talk at length about it, since the story is only half mine, but what I experienced was a loneliness and pain that nothing in my earlier life had prepared me for. My maternal grandparents had a sort of total devotion to one another (despite, or because of, a quite stormy relationship) that was lovely to see. My parents, though I always felt there were hidden shoals below the smooth surface which affected my being in ways I scarcely knew, nevertheless were very much 'a couple', hugely invested in one another and in the life of the family.

In contrast, Bill and I felt deeply, angrily, separate from one another, and the gulf was not bridgeable. Our attempts to bridge it left me always with a heartbreaking sense of failure and frustration. I so much wanted to be happily married, to make the kind of 'happy family' I still regarded as the norm. But we, or I, or Bill, or both of us, just could not do it. At the time I was baffled by it. Now I think that we were both looking for a parent rather than a partner, and resentful that the other would not take on the role.

Like most unhappily married people, I tended to feel at the time that the fault was largely in the other. I longed for some freedom from the pain of it all. Christian ideas on the indissolubility of marriage made it all seem particularly hopeless. I knew that the

promises Christians made in church were very solemn ones, almost impossible to get out of, it seemed to me. Yet I felt powerfully that I had married for the wrong reasons, and that even if that was culpable, as I believed it was, I had been young and very unsure of myself at the time; the punishment for the folly and the mistake seemed out of all proportion to the offence.

I tried out the idea of a separation and divorce on some elderly Christian friends, and was appalled at how horrified they were. Their general message was that I had made my bed and now I must lie on it. I should be behaving in an un-Christian way, it was cruel to Bill, it would be a bad example to others, etc., etc. I noticed that they did not appear to mind about the pain I was in, nor to listen to my argument that to go through the outward forms of marriage, to let people believe that you were committed in that way when you felt no inner sense of commitment, lacked integrity. On the one hand, I felt I was living a lie; on the other hand, I could not face the pain of separation—it felt unbearable. It seemed as if to achieve the wholeness I believed I wanted I had to go through with a divorce, and yet I felt I lacked the strength. I thought it was rather like one of those heart operations they used to do in which the possible danger of dying under the anaesthetic about matched the chance of coming through to a new life. I worried endlessly about possible damage to my children.

I started going to L., a Jungian analyst, in an attempt to sort myself out. I was disappointed in her, finding her too old, unnervingly forgetful, and once or twice indiscreet (if she let drop things like that about other people known to me, what did she let drop about me?, I thought). But I had some good dreams while I was visiting her. One of them concerned a public lavatory open to the four winds. I needed to use it, though I felt shy of doing so. 'It's divorce, isn't it?' L. suggested. 'You feel that it would be like shitting in public?'

I saw the force of the dream—divorce did feel like a public disgrace and humiliation—but I continued to delay, giving myself endless excuses. I loved the house in Norfolk; I couldn't risk damaging the children; I had much to be thankful for; it did not really feel *honourable* to go back on my marriage promises; it would upset my parents; etc., etc. I rehearsed all the arguments for and against many, many times, to myself, to my analyst, and to a few of my

long-suffering friends. Others, I have noticed since, seem to manage to leave partners with relatively little heart-searching, or with a comfortable sense that it is all the partner's fault. I found it more difficult than that. The worst thing—as, in a sense, in the dream—was giving up a particular view of myself as the sort of person who was capable of an unhappy marriage. It was a recognition of poverty.

Soon after we arrived in Norfolk my father died. I got a telephone call from a hospital in Buckinghamshire in the middle of the night to say that he had had a heart attack. I drove down straight away, much delayed by the need to find an all-night garage as I did not have enough petrol. I arrived at seven in the morning to discover he had died a quarter of an hour earlier. They left me alone with his body, the first dead body I had ever seen. I gently touched his face, and an old scar on his neck. The dead person did not look much like him; in fact, my first thought was 'That's not my father'. The essential person had escaped.

I minded very much that I had not been present during his night-long struggle for life, especially since my mother had left him as soon as he was settled into hospital. 'How could you leave him?' I could not prevent myself asking her. 'Well, there was nothing I could do for him, was there?' she said. I knew that it would have meant everything for him to be aware of her presence beside him, and it saddened me that none of us had been there. My father had spoken of death to me several times in the past few years. One Sunday afternoon when I was in the kitchen preparing the family tea he had said to me 'You know, I think it might not be all that long now'. 'Do you mind?' I asked. 'No', he said. 'I've had a good long innings.'

At the funeral my mother seemed unnaturally cheerful. She and my father had been married for 50 years and had enjoyed what is certainly thought of as 'a good marriage'. My sister and I, rather more tearful, felt baffled by my mother's determined looking on the bright side. Two months later, however, she collapsed and went into hospital with internal bleeding from an ulcer. It was noticeable that her sadness began at that point. She was weakened by the illness, fearful of death for herself ('What do you think death *is*, Monica?' she kept asking me, and I tried to answer), apprehensive about living alone.

Beneath her 'flapper' style, however, my mother had always had huge reserves of strength. She recovered, enjoyed taking care of the business matters my father had always handled—and did so meticulously—and told us that she found she quite liked living alone. 'You can do what you like, when you want to do it', she said. A year before his death my father had had an accident driving when he had knocked down a couple of bollards. After his death the Council sent in the bill. 'What will you do about it?' I asked my mother. 'Oh, I just wrote "Deceased" on the front and sent it back', she said. 'Serves them right for taking so long!'

If my marriage broke up, at least I should not have to share the pain with my father. With apprehension—she had always had a horror of divorce—I shared the possibility with my mother. Her response amazed me. 'Quite right, in your case. You should have done it years ago.' As always, she took me by surprise. She went on to say 'If there's any help I can give you—money, somewhere to stay—you have only to ask'. I wept. I had been so sure of her opposition.

The internal struggles went on. I made a new acquaintance, who became relevant to the issue. Norwich Cathedral held a small conference for contemplatives (very quarrelsome they all were, too) to celebrate the 500th anniversary of Mother Julian's 'shewings'. One of the contemplatives who came was David Shapland, a priest, who had left the paid ministry to go and found a small lay community in South Wales called Llanerchwen. We took to each other immediately. Later, when he and his family were having a holiday on the Broads they came and lunched with us. By the time they left, I had promised to go and stay at Llanerchwen.

It was a tiny community, just the Shapland family and Elizabeth Elphinstone. For a time I considered joining them, at their invitation, but there was not any available accommodation, and the practical difficulties felt too many. What was more important, though, was that David entered into all my doubts—religious, psychological, social and just plain sentimental. He heard me weep the whole impossible muddle out, and then said, quite simply and certainly, 'You must go'.

Perhaps I had needed a priestly blessing on the enterprise, perhaps it was more that for the first time I felt wholly heard and

understood, but from the moment David spoke I knew that I would go through with it. There were other periods of doubt and wobbly knees, but I knew that I had found, or he had found in me, the strength I needed to change.

I suppose you could say that my mother and David between them, parental figures both, in a sense gave me permission to do what I needed to do. Yet it also turned out to be true that, not at once but gradually, the decision to get divorced turned into a crucial stage in my growing up and learning to take responsibility for my own life. Since the Church, at least officially, could not support my decision, then I must learn to carry it for myself, to take the scary step of defying it because I believed this was the right and truthful action.

'Sooner or later, in order to grow up one has to deny Mother', said a shrewd friend to whom I described my dilemma about opposing Church teaching on divorce. 'And it's not a bit of good if you have to have her consent to do it!' I was aware after my divorce of an inner separation from 'Mother' Church that was not a rejection, simply an acknowledgement that she was not always right and that I had to use my own judgement. This would stand me in good stead in the next decade when the conflict about women's ordination intensified.

A further strand in my personal picture that the Church would not have liked at all was that I was in love and was loved in return. Perhaps because my marriage somehow did not bind me emotionally, I had been platonically in love a good many times in the course of my marriage, which was appallingly hard on Bill. I seemed no more able to avoid it than I might have avoided catching the measles, except that I never seemed to acquire an immunity. But the love with F. was different. It fulfilled me sexually on a level I had not imagined possible. There was an exchange of ideas, of thoughts, of jokes, of laughter. F., a German, introduced me to many new ways of thinking, challenged me in ways I had never been challenged before, released me from fears I had not realized I had. He could also be mean, envious and superior in ways that hurt.

F. was married, not happily, and he made it clear from the start that he did not intend to leave his wife—he had already left one wife and could not face all the implications of doing it again. In the beginning this troubled me very little. Later it became intolerable.

Late in 1974 I went to Llanerchwen and decided while I was there

that I would leave Bill. I applied for, and got, a job as a producer in the religious programmes department of the BBC—I did not particularly relish a job, but I knew I would need money in the changes that lay ahead of my family. I took a couple of rooms in Holland Park and began a divided life between there and Norfolk. Charlotte, who had finished A levels, was away in Israel working on a kibbutz, Alex was a pupil at Bedales. I tried to prepare Bill for my departure, and he responded with rage and (temporary) breakdown. It was agony.

I had expected it all to be painful and it was—excruciatingly. The sense of homelessness, of coping with a new job, of comforting my son (my daughter had long been urging me to leave), of worrying about financial problems, and, finally, of worrying about Bill himself, all hurt desperately. Finally, in 1976, F., threatened more than he cared to own by the fact I had actually left Bill, broke off our affair. I felt desperate.

There is one cherished memory from that time. One lunchtime I went to a drinks party connected with the BBC. There, for the first time, I met Rabbi Lionel Blue. Trying hard to conceal my sorrows, I chatted away, I thought lightheartedly, and arrived home at night to a telephone call from Lionel. 'I thought you seemed very unhappy today. Come round for tea on Sunday and we'll talk about it.' Later, when I got to know Lionel's intuitive capacities better, it surprised me less, but at the time it was amazing. Over Sunday tea, he surprised me still more. 'You're probably short of money', he said. 'People getting divorced always are. I could let you have £500, if that would help.' This extraordinary act of generosity from a man who had only known me for three days moved me deeply.

My mother, too, was wonderfully supportive. If I had wished to live with her she would gladly have made room for me, and if I had felt like asking her for it she would cheerfully have handed over her savings to me. Her kindness and understanding meant a lot.

I continued visiting L. I was not 'in analysis' as they say—I only went once a week or at the most twice—but I began to understand a little about how the method worked. After visiting L. for the first time, I had climbed on a bus with a sort of vision of a great weight lifted from my head. Like most people who have psychotherapy, to begin with I very much enjoyed the chance to talk endlessly about myself, and to have so much of someone else's attention. I was

fascinated by the dreams I was having and by memories which swept up from the early years of my life—what a lot of them!

L. was not the easiest therapist to work with. For one thing, although she had lived in England for many years, her English was atrocious, and sometimes I had to ask her to repeat a remark three times before I understood her. Only much later, when I had ceased to work with her, did I work out why that made me angry. L. was a highly educated woman with academic degrees from Berlin and Edinburgh, and yet she could not take the trouble to learn to speak English grammatically or with any kind of love for it. It came across as a kind of contempt for her adopted country, so much less civilized, she sometimes implied, than her beloved Germany.

Another quirk of L.'s, more understandable, was her hearty dislike for Christians and the Christian Church. The whole lot were lumped together into one indigestible heap. 'You Christians', she said to me once, 'you all . . .' Manners, not to mention truth, made it impossible to reply with an equally insulting generalization. 'You Jews, you all . . .'

She was also given to gnomic sayings which often had a slightly bruising quality to them, but which did not seem to help me very much. 'You've never really suffered', she threw at me once. What did it mean? That I did not suffer as the German Jews suffered? Fair enough. That I had pretended as I had told her of childhood and adolescent hurts and my conflict over divorce? I didn't believe it. I was aware of a great deal of suffering inside myself, which I had hoped L. might understand and perhaps relieve. Could she really not see it? My own life apart, could she imagine that any human being had 'never really suffered'? It seemed built into the very fabric of all our lives and relationships.

Such failures of L.'s made me more and more uncertain that she could help me, though my time with her eased me into the analytical method, and perhaps took me as far as I felt like going at the time. Finally I told her I was leaving her, and the following night I had an unforgettable dream. I was walking around a new house that belonged to me and with which I was absolutely delighted. Room after room pleased me, until I came to a locked door. When I got this door open, I found 30 toddlers asleep on the floor. 'When they wake up', I observed, 'they will cry.' I began telephoning social workers,

begging them to come and look after my flock of tearful children. 'No', they all replied, 'they are *your* children and you must look after them.'

Working for the BBC as a religious programmes producer, though a bit of a shock at first, felt a welcome release from my other preoccupations, as well as a needed source of money. The Beeb had changed surprisingly little since I had been a producer's secretary all those years before. I found myself sharing an office with Gerald Priestland, who had just come to work in religious broadcasting, and who had not long recovered from a severe nervous breakdown; and Ron Farrow, an old BBC hand, who proceeded to teach me my job with great kindness and skill. Gerald had dug himself into a corner of the office rather as I imagined he must once have dug himself into the corner of the room where he did prep at school. All sort of noises and diversions could go on over his head to which he remained oblivious once he had started writing his copy. Lacking a public school background, I found the constant coming and going of people—often for the sheer pleasure of exchanging witticisms with Ron, a wonderfully funny man—quite a strain. But after a few days of eyeing one another suspiciously, Gerry and I soon discovered that we liked working together, sometimes on the same programmes, and that we made one another laugh. In fact, the amount of joking and laughter that went on between Gerry and Ron and me was remarkable. We became regular lunch-time drinkers together, and Ron, a small man, said that being out with Gerry—6'7", and me—5'7"—felt like being on an outing with Auntie and Uncle. Once I remember Gerry telling us, rather movingly, of his breakdown, and of the help his Viennese analyst had given him. 'Here's to Sigmund Freud!' he said, raising his glass. 'May his Oedipus Complex never grow less', I continued. 'He'd be here now, only his mother wouldn't let him come', Ron concluded.

We gradually developed a private vocabulary. 'Cratchiting' was one of our words. Ron was always the first to arrive in the morning, and had usually done an hour's work before Gerry and I rolled in. A flexitimer before the word was invented, at half past 4 he would wind his muffler round his neck and slip off home. Never without comment, however. 'Give Mrs Cratchit our regards!' we would cry. 'And all the little Cratchits!'

The goodness and niceness of Gerry and Ron were a comfort in a rather gloomy time. I grieved for my Norfolk house. In London I spent my time in a curiously creepy couple of rooms, in what was known to my friends as the House of Usher. There was an alarmingly aggressive chimpanzee which often got loose and would spit and threaten to bite me if it saw me on the stairs. Desperately longing for something I could call home, I wondered whether I could realize an insurance policy and buy a cheap flat. My solicitor advised against—'It'll be worth, oh!, ever so much money if you keep it another ten years.'

Desperation caused me to ignore the solicitor and thus achieve the solitary financial coup of my life. I bought a nice flat down the grotty end of Ladbroke Grove for £10,000, which I sold four years later for £27,000. I felt as if my life had begun again. At the front of the flat was a long Italianate view across the Grove and down into St Charles Square. At the back was what Lionel called 'over the rooftops of Paris'. From the mews at the back I could hear Wings rehearsing, something which gave me great kudos with my adolescent acquaintances. I bought the flat just as my decree absolute came through.

I held a housewarming party to which Lionel came and said prayers. He gave me a silver mezuzah from Jerusalem, which I hung up over the front door. 'Was that a good idea?' my mother asked, with her usual practical flair. 'If there's a pogrom you'll be the first to go!'

A bright spot in what had been a dark time was the publication of my first novel *The Cat's Eye*, a novel about psychological projection, which has always interested me very much. It had some splendid reviews.

In the late 1970s I discovered America. I had visited New York in 1964 and been enchanted by the wonderful ethnic faces that filled the streets, so different from Britain where it was still unusual to see a black or Asian face. But now I was asked to go and speak at the General Theological Seminary in New York. There was also some question that I might write a book about Thomas Merton, and I thought I might pay a flying visit to Louisville and see whether this would be possible. So I took a brief vacation from the BBC. One night my hosts took me out to dine with another professor at the Seminary, Fred Shriver and his wife Susan. Later they were to

become very important friends in my life, perhaps the closest I have known, and my friendship with them would lead to many visits to the United States, and a deepening knowledge of that amazing country.

I went back to England and the BBC, and continued with my plans to write a book about Thomas Merton.

I decided to split my research into two long periods in Louisville, one in the autumn and one in the spring, with a period back in England between the two visits collating material. Going to Louisville was delightful. Kentucky, a beautiful rural state, was full of autumn colour when I first arrived, and Bellarmine, the Catholic college where the Thomas Merton Studies Center is situated, was a small, friendly place. The curator generously set aside a room for me in the Center, and each day I plodded through the material.

I have always found it hard to define the particular pleasure I take in Merton, since in some aspects of his life and work there is, at first sight at least, a sort of narrowness that is disconcerting. In his early years as a Trappist, when he was still intensely idealistic and full of rosy ideas about monasticism, he could be horribly superior about 'the world' and all its habits. What is so interesting about him, however, is that he changed—and the change is charted in his many writings—from a callow young man to a great-hearted and generous human being, intensely interested in every aspect of human life. It must be said that it was monasticism, bitterly as he chafed against its constrictions at times, that brought him, by circuitous routes, to this radical conversion.

The bigot who once thought Christians ought not to read news-papers or listen to the radio turned into a man to whom nothing human was alien and who was passionately concerned with politics and world peace. Methods of healing of the desperate rift between East and West during the Cold War became a major preoccupation, but alongside that he was fascinated by a different form of the coming together of East and West—helping Christianity and Bud-dhism to listen to each other's religious languages. He plunged courageously into the darkest places of human cruelty and suffering. He read all the material coming out in the 1960s about the Holocaust, and tried to understand the deep causes of this nadir of human life in the heart of 'civilized' Christian Europe. So far as an enclosed monk could, he involved himself in the Civil Rights and

Peace movements, to the dismay of his superiors. He explored, and encouraged his monastic students to explore, every aspect of the culture of his time that gave clues for understanding—in particular he read widely in literature and poetry.

Towards the end of his life he wondered, and even had dreams about, the way women had been ignored and subjugated with Christian culture, and as if this was the only way he could realize the feminine within himself, he fell in love with a woman.

What was compelling to me was his 'bigness'—of ideas, of understanding, of ambition in understanding the world and of comprehending the meaning and uses of Christianity within it. Without trying to do so, he showed up the poverty, the intellectual and spiritual sterility of much contemporary Christian thought, its fearfulness about art or about engaging with real issues.

What also fascinated me was his experience as a hermit, which fed into recurrent fantasies of my own. Ever since the 'God-experiences' in my late teens and early twenties, I had had a secret feeling that if only I could create a space, a time in my life in which none of the ordinary preoccupations of work and family and money and seeing people came first, then maybe I could continue the experiences. The door which had once opened a crack for me, and which had remained ajar, might open wider. The price for a deeper God experience seemed to be an extensive experience of loneliness.

Merton was in fact rather ambivalent about being a hermit. He did hugely enjoy the peace and quiet of his cinder hut, the chance to read and write and pray as the will took him (after the meticulously structured years of Trappist life) and the closeness of the natural world—hills and woods and deer. Yet, paradoxically, the years when he was a hermit coincided with some of the years when he was enjoying social calls with friends in Louisville, and when he admitted quite a large number of visitors, and seemed to need the intellectual stimulus that they brought him. I recognized one resemblance between Merton and myself (it is impossible to write a book about someone without making these sort of comparisons) was an intense sociability, a huge pleasure in company that perhaps needs to be balanced by long periods of being alone.

One of the pleasures of being in Kentucky was that I did have long periods alone, since when I was not working in the library there was

scarcely anyone in Louisville I knew. This felt wonderfully thera-
peutic after the previous active years, a chance to refind aspects of
myself.

Getting in touch with myself often, for me, involves travelling, and
this time it meant exploring Kentucky, a wonderful state of farms
and horses. I particularly enjoyed Pleasant Hill, the local Shaker
village which Merton had admired. Nowadays it is no longer a
working Shaker community—its generosity in caring for sick and
homeless soldiers after the Civil War reduced it from prosperity, first
to poverty, and finally to collapse. But its buildings are extra-
ordinarily beautiful, and include a wonderful curved staircase built
by an 18-year-old Shaker architect. It was difficult not to feel that the
Shakers held a secret of simplicity and modest living that recalled a
lost America, or perhaps simply a humanity that we are all near to
losing. It is easy to see why it appealed to a Trappist; Shaker design
declares that there is a beauty that is only found within an austerity of
taste.

The following spring I returned to Kentucky feeling grudging
about turning my back on the English spring. I need not have
worried. Nothing could have been lovelier than the spectacular
glories of the Kentucky spring, with hundreds of dogwood trees in
glorious flower and violets underfoot. Inevitably I got taken to the
Kentucky races and drank mint julep. I played truant a lot, working
in the mornings and going off to roam the countryside in the
afternoons.

Merton was published in America in 1980. It had excellent advance
reviews in *The Kirkus Reviews* and *Publishers' Weekly*, those twin
harbingers of a book's fate, it got front-page treatment from
Francine du Plessix Gray in the book section of *The New York Times*,
and a lot of warm recognition elsewhere.

Towards the end of my time at the BBC, I had been taken by John
Lang, my head of department, to a 'do' held in the higher echelons
of the BBC. Alec McCowen was to repeat the reading of St Mark's
Gospel he had already been giving in the theatre, in order to record
it for Radio 3. He had particularly requested an audience and we
were that audience. At the dinner the BBC gave after the show, I sat
beside Ronald Eyre, the theatre director and broadcaster, who had

97

recently completed his series about world religions, *The Long Search.* I later discovered this was not entirely an accident. Ron had read my novel *The Cat's Eye,* had liked it and wanted to get to know me. He had deliberately rearranged the seating plan to sit beside me.

Ron's charm was immense, he was witty and knowledgeable and had a gift for putting unlikely things together in a way that illuminated them. Somebody at the table mentioned *Mrs Warren's Profession,* a play which Ron had directed effectively in the theatre. 'It's Old Mother Riley and her daughter Kitty', Ron remarked, recalling an unpretentious film series of shorts that had been popular in the 1930s and 1940s. This particular remark, and what it revealed about Ron's way of thinking on a lot of different levels at once, captivated me.

The producer had invited Ron, Alec McCowen, and one or two others to his flat for champagne after the show. Somewhat to our host's dismay, I imagine, Ron insisted that I came too, and he was later to insist that Alec McCowen drove us both home. Going up Ladbroke Grove I remember feeling sad that I should probably never see Ron again. Instead, it was the beginning of one of the most intense friendships of my life.

6

My fifties began with renting a house on a Greek island—Hydra —for a couple of months, and inviting various friends, my children and their friends, my mother, Ron, to come and stay. I had never before been to Greece, and nothing had quite prepared me for the grace and ease of the way of life. We were part of a village and part of a way of life that had continued much as it was for centuries. In some ways it was not so very different from a Norfolk village, except that people seemed more lighthearted. I remember seeing families setting off for a day's picnic on a saint's feast day, Granny and various other relatives walking beside a donkey hung with food, wine and a musical instrument or two; in the evening we would see or hear them returning, covered in flowers and singing together.

The house I had rented was beautiful—up flights of stone steps (baggage had to go up by donkey), with a cistern beneath the dining-room floor, which collected rainwater, and in the days before the town had a proper water supply was the only source of water for those who lived in the house. It was useful for dinner parties—you tied a rope to the neck of a bottle of white wine and lowered it into the icy depths of the cistern until it was time to open it.

The rooms were big and bare, with pretty antique furniture. There was a lovely garden with a lemon tree—when we needed lemon to go in a drink or to squeeze over fish we just went out and picked one. But the best thing of all was the roof. It was so designed that at any time of the day it was possible to sit in the sun: there was a breakfast bit of roof, and an afternoon bit of roof, and, finally, some roof for looking out over the sea and watching the sun go down. Sitting up on a roof (not always ours) drinking, watching the sun go down and the stars come out was the way every day ended. It was unbelievably peaceful.

On one such night I remember someone remarking that the stars

were in the same position as at the time of the birth of Jesus. 'It isn't going to happen *again*, is it?' asked Ron gloomily. I laughed as I was meant to, but it touched on something fearful, angry, yet also wistful about Ron's attitude to the Christian religion, a painful inheritance from a Primitive Methodist background in which, in Ron's phrase, you were 'never good enough'. Religion mattered greatly to him—that was obvious in *The Long Search*—but he could only live with it with a lot of cynical jokes, often very funny. Buddhism had become a kind of consolation to him. He had visited the Zen Center in San Francisco to make a film, and under Baker-roshi's tuition had learned how to meditate. He did meditate, fairly assiduously, for the rest of his life—the black meditation cushion was well worn, I noticed—but he was often very scornful of the Buddhists. 'They're a smug lot. That's because Buddhism is the smart thing. At least there's nothing smart about the Christians, and that gives them some hope of salvation.'

Ron began to rehearse *Beatrice and Benedict* at the Buxton Festival, and I went up to Buxton to spend the previous week there. I did not know the opera at all, and I loved sitting in on the rehearsals—Ann Murray and Philip Langridge were singing the principal parts. In the late afternoon I would go back to the flat and rustle up a large meal for Ron and myself and any young and hungry members of the chorus he thought looked as if they were in need of a square meal. The final performance was a joy—beautiful singing, witty production, and an enthusiastic audience.

In the autumn of that year I drove Alex and his possessions to New College, Oxford for the start of his undergraduate years. It was a glorious sunny day, the New College garden looked amazingly beautiful, and for a few moments I was overcome with rage and envy at whatever it was—class, bad luck, being a girl, my own hastiness and folly—that had kept me from Oxford. I was surprised how much I still minded.

Charlotte had qualified as a state registered nurse and had gone off to Africa. She nursed in Johannesburg and later in Cape Town, and eventually did the overland trip by truck from the Cape to Egypt. The whole journey took her two years, which gave me two years of marvellous letters from her, describing her wonderful, and sometimes dangerous, adventures.

Earlier that year I had almost unwittingly joined myself to a cause

that was to have important consequences for me. When I had been physically unwell a few years before, Dr Una Kroll had treated my symptoms, and we had had many long and interesting discussions about religion, feminism, women's ordination, and similar subjects. Although I had always had feminist sympathies—I could remember in school history lessons passionately wishing I could have been a suffragette—the big feminist movement of the 1970s had left me largely unmoved, mainly because I was so immersed in my own problems at the time. On the subject of women priests I had, like so many women, taken up a position of apparent indifference or neutrality many years before. Daphne Hampson, a few years ago, told me of her fury when, at a dinner party in Scotland in the late 1970s, questioned about women's ordination, I said that I was largely indifferent, that I thought there were more important questions, etc., etc., a set of arguments I have since listened to many times.

When I remarked to Una that I did not feel discriminated against as a woman, she remarked mildly that I sounded like Queen Victoria, inveighing against the wicked folly of women's rights. 'You may not suffer from discrimination', Una said, 'but what about making an act of solidarity with all the women who do?' Because Una lived out her beliefs in such a costly way, taking up the cause of women's ordination in the late 1970s when the very idea brought ridicule from all quarters, I had to listen and to look at myself.

The Movement for the Ordination of Women (MOW) was founded in 1979. Tagging along with Una, I went along to a preliminary discussion at Diana Collins' house in Amen Court. I cannot have made much impression on the small gathering there because I was left out of future plans. The next thing I knew about was a huge meeting during July Synod week at the Church Commissioners on Millbank at which the great and the good—members of both Houses of Parliament, bishops, lords and ladies, famous names—turned up several hundred strong to hear Christian Howard read and explain the constitution and to start the Movement off. I suspect the *imprimatur* of this particular bunch of people was probably very important, but it was a po-faced meeting, with a hatted lady from the shires informing us that ladies must always take care never, never to be ungracious. ('Some of us were not gracious to start with', Sue Dowell unforgettably interjected.)

It is my impression that, having done their duty, most of the great and the good did little more for MOW after that apart from signing an occasional letter to *The Times*, but I think now that was a blessing. What women needed to learn was to look properly to their own well-being (as men do), and not depend on powers-that-be, fathers-in-God, bishops, or male mentors either, to tell them what to do or to do it for them. It is their own muscles which need to be flexed, their own risks which need to be taken.

I had joined the newly formed MOW but nothing very much seemed to happen for a bit (though the Movement was properly establishing office space and an administrative basis). I continued with my own inner struggles. Gradually, and with pain, I recognized that my refusal to examine the subject came from my fear of the ridicule I saw being heaped upon Una. I recognized then, and have since observed it repeatedly, that many women's refusal to be described as feminists is due to a similar fear. They have everything to gain by insisting on education and opportunities and a decent life for all women, yet the most ancient of male weapons against women, that of ridicule, along with the fear of not being admired, of not being sexually appealing, keeps many unwilling to face the serious issues involved.

As I began reluctantly to think about these painful ideas, and to recognize the way I had blocked off and denied the limitations being a woman had imposed on me, I realized what an appalling example the Church itself had set, reducing women for centuries to silent figures sitting with their heads covered. That certain great women had risen above these constraints did not make the constraints less offensive. No wonder Teresa of Avila said that when she remembered she was a woman her wings drooped. The most significant thing, it seemed to me, was that a woman was not allowed to stand at the altar and handle the sacred objects, the Body and Blood. I did not understand all the implications of it, but I sensed the underlying superstition that women were unclean, associated for men with sexuality. Precisely what had so often troubled me in the Church—the separation of spirituality and sexuality—was thus perfectly expressed.

Phenomena that I had often found distressing came to mind. Fr Z., a priest famous for his 'spirituality', had several times been in

trouble for picking up men in public lavatories; Fr B. had narrowly escaped conviction for touching up little boys; Mr A. had slept with half the women in his parish. Here were signs that 'holiness' was used not to heal and integrate the wounds of the psyche, but to deny them, shut them out of consciousness, until they erupted in some painful way that brought devastating shame to the men involved, and scandal to the Church. It was this healing of the split which the sight of a woman, the descendant of Eve, at the altar might symbolize and also help to bring about.

I had just about got to this point in my thinking when I overheard a conversation. I was at a party in the students' common-room at Queen Mary College in Mile End where Ieuan Davies was the chaplain. I heard a woman I scarcely knew at the time—Kath Burn, who later went to America and became a priest there—talking about the Petertide ordinations just about to happen at St Paul's. 'We asked the Bishop of London [Gerald Ellison] if he would say a prayer for all the women who would like to be ordained but could not be, and he refused. He said it would be a political act.' I am not sure why these two sentences galvanized me in the way they did, but they infuriated me. I thought of the powerful entrenched orthodoxy of the Church of England, and the ludicrous idea that this could be challenged by one gentle prayer. Improbably for me—I have never quite got over my telephone phobia, particularly where demanding conversations are concerned—I said that I would telephone the bishop and ask him to think again.

I did not, of course, get further than his chaplain, who made a rather dismissive remark about ordination services not being suitable places for protest. I said that if official protest was not allowed it rather created a need for unofficial protest. Anything of *that* kind, said the chaplain, would make the bishop exceedingly angry.

So we went ahead. Susan Dowell and Linda Hurcombe, Frances Killick and Kath Burn, Ieuan Davies and Ian Ainsworth-Smith, both clergy (Ian, it turned out, had helped train a number of the young men being ordained), Robert Wilson and myself obtained seats for the south transept of St Paul's, abetted by an eminent Fifth Columnist inside the Abbey. He gave us a useful bit of advice— 'Don't attempt to shout anything out. No one can hear a thing inside

St Paul's without a microphone', and an interesting piece of historical information. 'The suffragettes protested inside St Paul's, you know. They were thrown brutally down the steps outside, and one of them had her arm broken.' Ominous in its way, but it was good to know we were treading where the suffragettes had trod.

We sat together in the front of the south transept. At one point one of the suffragan bishops, sent by the Bishop of London, came to speak to us, asking that if we were planning any sort of action we should give the idea up. He spoke to Ieuan, one of the two clergymen. Ieuan pointed out that I was the leader of the group, and that he should direct his comments to me. He did not do so.

What we did not want to do was to spoil the most solemn moment of the ordination for the young men. So we sat patiently through the sermon—ironically it urged social justice—then through the ordination process itself. It was only in the singing of the psalm after the ordination that we took any action. Robert and I walked across the huge space beneath the dome and held up a banner saying simply 'Ordain women'. Working in twos, the others each held up their banner, one on each side of the nave, one in the south transept itself. Linda and Susan were hustled out almost at once, and hung their banner high on the statue of Queen Anne so that it was seen immediately by anyone leaving St Paul's.

Robert and I got left till last, eyeball to eyeball with the entire clergy of the London diocese, a situation which might have been funny in another context. We stood there for about ten minutes before a wandsman tapped me on the shoulder and said 'Game over!' We moved quietly and without resistance down the aisle, naturally showing our banner to members of the congregation on the way—but not quickly enough for one of the wandsmen, who began beating Robert on the shoulder and was plainly terribly excited by the whole procedure.

The cathedral was packed—there must have been several thousand people there—and some of them at least were sympathetic to our cause, as we discovered when we stood outside afterwards. But, caught up in the peculiar restraints of the situation, nobody moved or protested on our behalf, or tried to stop the wandsman beating Robert—with the unforgettable exception of an honourable young American Methodist minister, a complete stranger, who jumped up

out of the congregation saying 'Stop that!', and accompanied us out into the street trying to dissuade the wandsman.

His name, I discovered later, was Andrew Weaver. He was from the Napa valley in California, and a passionate believer both in justice and in women's orders. Knowing the power of the crowd mentality, I still remember his simple, brave intervention with love and admiration. He was to become a good friend, whom I visited several times in northern California, and more recently in Los Angeles.

Our demonstration got itself on to television and radio all over the country, and *The Times* asked me to write an article, which appeared in the newspaper the next day. The bishops were plainly very angry at our action—none of them would speak to us after the service, though a number of them were known to us personally.

I found that the ordeal had been emotionally costly. Sensing how undone I felt when the service was over, Ieuan asked me to lunch with him, and to my dismay I found myself drinking glass after glass of wine in a kind of shock reaction. I am not a heavy drinker, and I was astonished at my own behaviour. When we left the restaurant I could barely stand, and Ieuan walked me round to some friends of his he had known when he was a curate, and rang the doorbell. When they answered he said 'This is Monica Furlong. Could she have some black coffee and lie down somewhere?' Several hours later I pulled myself together and went home.

Naturally there were repercussions. MOW, which had been fairly quiescent since it had brought itself into being, was torn with dissension. Was such an action unladylike? Or, in a favourite phrase of those who disliked radical action, 'counterproductive'? Or was it the only way to make the Church sit up and pay attention, largely because it embarrassed them to have the world see it wash its dirty linen in public? Personally, I never had any doubt that embarrassment was the only route that worked. We did not lack bishops and others who made reassuring noises of the 'Don't you worry. Just leave it to us and we will see to it' kind, but it was clearly a long way down their agendas. In any case, what mattered was that women should stop regarding bishops and clergy as kind Daddies, which, where women were concerned, they often weren't. A certain childlike subservience often seemed to be the price of their help (although there were always one or two fine exceptions to this).

It was MOW's fortune to have a suffragette as a member, Victoria Lidiard, who was, I believe, the last suffragette alive to have been imprisoned in Holloway. Before she died, in the early 1990s, Victoria used to write me letters which went 'Only one thing works, to push and go on pushing. When you stop pushing they stop changing.' The truth of her words grew on me with every passing year of the women's ordination debate.

The immediate effect of the St Paul's demonstration was that the Archbishop of Canterbury, Robert Runcie, asked me to go and see him at Lambeth, and to bring some other women with me to discuss the issue. Diana McClatchey and I got a group of eight women— some of them older like Deaconess Elsie Baker who had served in the ministry of the Church and wanted to be a priest all her long life, and some younger women, like Chrissy Ross, just off to theological college and wanting to be ordained. (Chrissy later gave up what felt like the hopelessly protracted Anglican struggle and became a Methodist minister instead; she was one among many, many gifted and creative women whom the Church of England simply wasted in those years.)

The Archbishop received us with his usual charm and courtesy, and listened with great politeness to all we had to say. He promised that he would remember what we had told him in future discussions of the subject. But his real feelings about women's ordination soon emerged. How could we possibly want to do something which might split the Church? I don't think he actually said that it was a selfish desire on our part, but that was certainly the implication. For the first, but not the last time, I was startled by the Archbishop's belief that although something might be right, there was no pressing reason to make it happen. What astonished me still more was his total inability to see it as women with a vocation saw it. I don't myself have any wish to be ordained and never have had, but I can imagine the power of the feeling to those for whom it is a calling. Yet the Archbishop, a priest himself, could conclude that women who felt a vocation like his own should suppress it and deny it. For the first time since I had become a Christian I caught a glimpse of something I would come to see much more clearly in the years to come—that in the Church women are not quite real people, or at least not as real as men. They are perhaps the Gentiles over against whom male

priests can discover their own specialness and purity. They are the 'Other'.

MOW began a series of actions at ordinations, usually standing outside and giving people flowers and pamphlets about women's ordination. In Southwark Cathedral, with the bishop (Ronald Bowlby)'s agreement, a group of women deaconesses got up and walked out of the ordination service at the point where, in other circumstances, they would have been ordained, and they held a 'wilderness liturgy' of milk and honey in the churchyard outside. At least one of the suffragans had tried to oppose this simple action and had threatened a woman deacon with legal action.

The move from silent 'putting up with it' to resolute action seemed to bring a wave of creativity to the women and their male supporters. Suddenly there were special services, specially written liturgies, satiric entertainments, money-raising activities, theological papers written about women and theology. Some of these, as I remember, had touches of unconscious comedy, as it took women a while to realize that they too could speak and pray in church. Some of them were turgid and earnest—it took us a while to learn that the way to disarm oppression is very often to make jokes and to laugh. But some were fresh, true, deeply moving. I remember an all-night vigil for women's ordination in Southwark Cathedral which was most loyally attended by, among others, a distinguished judge who was always a good friend to us, and several MPs. The Eucharist at midnight was celebrated by a man, which couldn't be helped, but the readings were by another man, and not a single woman's voice was heard. (To make it even odder, the celebrant insisted on doing much of the service in Maori—a language with which few MOW members were familiar—on the grounds that women, like the Maori, were an oppressed group. To some of us the service was a form of oppression in itself, but not without its giggle-quotient.)

In the early hours of the morning, suddenly feeling rather tired, I lay down for a little while on a carpet in one of the side chapels. After a while I heard somebody breathing on the other side of the altar. 'Who's that?', I asked. 'Una.' 'Monica.' 'Monica, love, who'd have thought we'd both be lying on the floor in Southwark Cathedral in the middle of the night. The things we do!'

In 1982, already Vice-Moderator of MOW, I was elected Moder-

ator. The previous Moderator had been a bishop, Stanley Booth-Clibborn, but when he said that he thought the leader should be a woman, and I warmly supported him, I found myself with the job. Because many people, both women and men, from a wide spectrum of church opinion, supported women's ordination, we had a large and contrary constituency to please. The divide was not, in fact, so much to do with churchmanship—Anglo-Catholics or Evangelicals had thought their theological position through fairly carefully before they got as far as joining MOW—it was to do with conservatism or radicalism. The conservatives, like the gracious lady at the opening meeting of MOW, wanted respectability, or at least they thought most of our efforts should be directed at getting helpful Measures through Synod. They were particularly anxious that we should not behave in such a way that we alienated Synod opinion. We had a number of women in MOW who played an important part in Synod proceedings, and were clever and wily in its cabals and committee-rooms, and it would have been folly indeed not to have valued their expertise, but they were heavily addicted to caution.

The radical movement of MOW saw it rather differently. The issue of women's ordination had already been fairly actively discussed in the Church for around 60 years, and had broken the hearts and wasted the gifts of able women like Maude Royden. There was apparently little to show for all that heartache, and nothing was easier than for the Church to ignore the women's pleas with excuses of 'more important issues' and leave everything exactly as it was. You could play the chess game of Synod till hell froze over and know that you would never win. Our attempts at 'action' (invariably reported on television and radio and in the newspapers), which caused cries of horror and outrage from conservative members of MOW ('It'll be counterproductive') always seemed to speed up dialogue and informed comment.

Gradually I noticed that the media, who had mocked Una Kroll and Elsie Baker with the savagery reserved for the first generation to step out of line and do what is not expected of them, were coming round to our point of view. A problem was that few of them really grasped the complexity of the issues. They could not imagine why a woman could not be a priest, and because they knew that the Free Churches ordained women ministers, they tended to think the cause

was won in the C. of E. So the task, it seemed to me, was to woo the media, to educate them, to keep them informed of our actions, and to use them as a source of embarrassment for a Church which would do anything short of actually changing its attitudes to women.

Margaret Webster, the Executive Secretary of MOW, was very much the administrative heart and soul of MOW, nearly always sturdy and cheerful even when things were going badly, making us at home in St Paul's Deanery, with Alan's marvellous co-operation, in a way that made their house almost an extension of the MOW office. She and I, with a lot of help, worked on the public education programme, encouraging members to produce pamphlets, papers giving theological arguments, a newsletter, and eventually a magazine called *Chrysalis*. We had among us a number of gifted people—writers, artists, designers, respected theologians, journalists—and we tried to use their gifts to the full.

MOW was, to a surprising extent, a lay people's organization. I do not, of course, mean that many clergy did not join, and that they were not a source of wonderful support to us, but deaconesses in particular were sluggish about being identified with us, or even joining (though glad enough of our labours, of course, once the victory was won). I like to think their consciences smite them painfully, because they certainly would not be where they are if it were not for the hours many of us who did *not* want to be priests freely gave to sit on committees, to write letters and articles, to talk to journalists, to spend hours on the telephone, and generally labour for small reward.

Of course, we received the usual quota of mad letters and public insults, but fortunately the interest of what we were trying to do soon outweighed the tedium. What *were* we trying to do? I think if it had just been a question of getting women ordained, I would not have stayed the course. The point of getting women ordained, from my point of view, was that it forced the Church to re-examine ancient prejudice and stereotypes which had remained untouched at the back of the cupboard for centuries, and which had, tragically, spilled over to affect a whole society's attitudes to women.

While I had dimly known this from the beginning, I began to see it with real clarity as I started attending the Synods where women's measures were discussed. The degree of fear and loathing of women

that emerged, particularly in clergy speeches, particularly at the Synod of 1984 (later they learned to be more wary about expressing the venom in public), showed me that what I had intuited was a much more powerful influence than I could possibly have guessed.

To sit in Synod and hear my bishop announce that he saw women priests as 'an ineradicable virus in the bloodstream of the universal church' (this was in 1984, just as the full horror of the AIDS virus was becoming known in this country) was to witness church skeletons fall out of cupboards and cats come out of bags. The very naïvety of such speeches from sophisticated churchmen showed how unconscious were their feelings towards women. And these hostile feelings needed to be made conscious.

Just as interesting as the venom of the men was the venom of a group of Anglo-Catholic women as they started forming organizations to oppose women's ordination. We discovered quite soon that they had demonized us. Women journalists would come to see us after visiting the groups of hostile women and be amazed to find us not in dungarees and bovver boots. In fact, both Margaret Webster and Margaret Orr Deas who worked with her in the office took a great deal of trouble with their appearance, and were as far as can be imagined from the 'butch' image their detractors tried vainly to promote. (Margaret Orr Deas later became properly recognized as the extraordinarily beautiful and feminine woman that she is by no less than the arch-opponent William Oddie, who described her in the *Evening Standard* as a 'classy filly'. Without quite rising to such heights either of beauty or of attractive dress, I tried at least not to let the side down.)

But in spite of venom, angry campaigns, concerted opposition, and (almost worse) bumbling liberal approval that thought 'the time was not ripe' and always tried to stop short of getting down to brass tacks, the ordination of women came about. In 1992, those of us waiting outside Church House for the result of the vote (they had closed the public gallery to exclude us) learned that the Measure for Women's Ordination had gone through. We opened champagne bottles, let off rockets, and sang.

Fortunately, we did not then know that the bishops, who had already permitted huge and damaging concessions to the opponents of women's ordination in the legislation, would continue to bow to

those opposed to women ('bend over backwards' was the way the bishops put it themselves—do they never analyse their own language?) and would continue to make more concessions that would undermine the Measure to ordain women to a worrying extent. These they enshrined in what became known as 'the Act of Synod'. Plainly they felt the women had had their turn, and now should be grateful and ready to put up with further indignities.

Privately they were saying that everyone would soon get used to women priests and there would be no problem, a suggestion as two-faced as it was improbable. Privately, too, there was much concern that if many priests left, the Church could not afford to pay the large sums of compensation that had been rashly promised. Publicly there was much cant about generosity and inclusiveness. At the 1993 November Synod a number of women, and one or two men, clearly felt uneasy about it all, but in a reply to a direct question about what would happen if the Act of Synod was not passed, the Archbishop of York, using a nautical symbol, said the ship would sink. It was a brave member of Synod who would vote for a Measure designed to demolish the Church of England, though a few did.

What the Act revealed was how crucial the laity have become in maintaining some element of freedom of speech and criticism in the Church. Many male clergy, and a number of women deacons who were strongly opposed to the Act of Synod, felt unable to speak up because, as they admitted in private, it would affect future appointments. (Certainly, gifted priests who have spoken boldly and bravely over the past ten years on unpopular issues have found themselves passed over for future appointments. Those opposed to women priests, on the other hand, have been guaranteed continued appointments.)

In 1984 a group of Australian women asked me to come and help start a Movement for the Ordination of Women there. I visited Brisbane, Sydney, Canberra, Melbourne and Perth and developed a love for the place and the people that has taken me back there twice since. I still remember the astonishment of seeing the Outback in New South Wales, hundreds of miles of country untouched by human beings and alive with kangaroos and other wonderful animals. It had a strange intensity about it that at times made me feel as if I was taking LSD. On my second and third visits I stayed with

Aboriginal communities—one in tropical northern Queensland, one in a desert of Western Australia—and saw the power of living myths even in communities whose traditional life had been hugely changed.

Deserts are very special places. One of the most important happenings of my life, in one of the most important places in my life, occurred on a holiday in a desert with Susan Shriver in 1984. We met in Los Angeles, hired a car, and drove across California and Arizona to New Mexico, where Graham and Sue Dowell were doing a locum. Unexpectedly, an acquaintance in Los Angeles offered to lend us a cabin in the Mojave Desert, and since we had plenty of time, we jumped at the offer.

The cabin, an ex-prospector's hut, stood by itself at the base of the Chocolate Mountains with no habitation in view. It consisted of two rooms, a sitting-room/kitchen, and a sitting-room/bedroom. It was barely furnished. By day we piled up two strips of foam rubber and made them into a couch, and at night we put them down on the floor and slept on them. In the kitchen there was a terrible old stove. If you wanted to cook you went out into the desert, gathered up some dry bits of plants, put them into the stove, and set light to it. There was just about time to boil a kettle or fry a meal before the fire died down.

The cabin was surrounded by sand and by beautiful plants, of which we gradually learned the names. There were barrel cactuses, many of them in flower since it was April and the annual rains had just finished. There were the majestic crown-of-thorn bushes, with their savage spikes and blood red tops. There were scented creosote bushes with the bees buzzing in them, and there were the lovely palo verde trees. In the 'wash'—the dried up river-bed through which the rains had recently poured—there were tiny flowers, baby lupins and tiny vetches in blues and pinks.

There were doves and owls and hawks and hummingbirds and lizards; there was a fine young rattlesnake that sunned itself in the backyard every morning; there was a black-widow spider nesting under the kitchen table; there were scorpions; and, to our endless exasperation, there were tiny and rather pretty mice-like creatures with fluffy tails which overran the whole place, and even appeared in our photographs! They were a little nervous of us at first, and on the

second day they got into the aspirin supply, which quietened them down for a bit, but after that they took to us with enthusiasm, and frequently ran over us as we lay in bed, something I never got used to.

We arrived at this magic place a little before sundown. At first we were dismayed by the silence and the loneliness of the desert. It seemed entirely empty—only later did we discover its teeming life—and we could hear the wind sighing, moaning slightly, over the mesa. 'You can see why people thought the wind was the voice of God', Susan remarked. We went inside, lit the kerosene lamp, cooked supper for ourselves, and went out later to pee on the sand, carefully carrying torches to avoid stepping on snakes. The stars were close and vibrant.

The sun woke us next morning as it bounced over the mountains. We did not know it—we had put our watches away—but it was half-past 3. The mice were already up and busy in the kitchen, rustling through the aspirin box.

The desert was cool in the early morning and at twilight, very hot at noon, and cold at night. Trips to the oasis—a proper oasis with palm trees and a spring—to fetch water were done in the early morning, and gentle strolls were taken just before dark. In the middle of the day it was too hot to do anything but lie on the couch, watch the hummingbirds, talk, read, write, or play on a psaltery we had discovered in the cabin and were teaching ourselves to play (we got to be very good at 'The Old Grey Goose She Ain't What She Used To Be'). Another pastime, when it was not too hot, was raking the sand of the Zen garden our Buddhist hosts had built outside the cabin.

We had brought supplies of food out from LA—simple meals of rice and pasta with vegetables—and learned to cook with the mice scurrying like cats round our feet. At nightfall we lit a taper to the little Buddha who sat on the mantelpiece and bowed to him. We certainly lacked 'mod. cons'. Our water supply, since it was fetched by hand, was eked out carefully. We used it first for washing-up, then for washing ourselves, and finally distributed it carefully among nearby plants.

The absence of a lavatory had felt vaguely worrying before I arrived. I felt reluctant at the thought of having to shit out on the

sand, not because there was the slightest danger of being observed, but because, I suppose, it felt crude, uncivilized. I was surprised to find I enjoyed it, that it brought me close to nature in a way I had not anticipated. The desert is a place of wonderful economy, where every drop of water and every scrap of nourishment is savoured gratefully. Scarcely would I have finished before tiny insects would appear, carrying off their treasure trove or devouring it on the spot with every sign of pleasure. I began to recognize what civilization had forced me to forget—that I am part of a cycle of nature. On one hilarious occasion I peed not far from the woodshed. I had already begun when, to my horror, I noticed a huge, scaly leg sticking out from under the shed. The noise of my peeing startled the creature—a very large lizard rather like a baby dragon—and it ran straight towards me, which frightened us both about equally.

Other trappings of civilization fell away. Because it was so hot, and because there was no one else around, we gradually got out of the habit of wearing clothes. They seemed to have no purpose. One day, however, I was walking idly along the wash, botanizing among its minute plants and flowers, when an American Air Force helicopter passed overhead, came down low, and followed me for a few minutes along the wash. I took control in the only way I could think of, which was by totally ignoring it.

After about three days I became aware of a new, yet ancient feeling. It was a rare and special kind of happiness which came, I thought, from not having any sense that there was something I ought to do. Apart from keeping clean, eating, shitting, there was nothing it was necessary to do, and it felt like a wonderful refreshment—a sort of primal sabbath. One day I looked out of the window at the Zen garden and saw a small creature rushing past on some errand of its own—a desert rat, I think. It struck me that we had been trained to find wild animals frightening, disturbing—a threat—but that none of them bothered with us until we troubled them. We co-existed perfectly happily with the rattlesnake and the black-widow spider.

Perhaps it was because so many taboos were broken on that holiday, and so many habits and routines disturbed, or maybe it was that so many good Buddhists had used the place, that the cabin and the desert yielded a particular sort of truth, the sort that Alan Watts

often spoke about when he said that a person was not just an isolated bag of skin walking about. On one of the long hot afternoons, half-way through speaking a sentence, I made an extraordinary discovery—that I was hearer as well as speaker, that I was Susan as well as myself, but that I was also everything else—the desert, the creatures, the strange snake-like grain of the cabin wall. For a while I moved in and out of this awareness until it became frightening and I preferred to return to being my normal self. There was a power there that I was not ready for, but I suppose I was ready for the moments of awareness or I would not have had them.

In 1987 I published a book about Thérèse of Lisieux at the suggestion of Virago. I have always been interested in Thérèse, but I am even more interested in finding a way to think about saints which is not hagiographical, which accepts that their neurosis, and in some cases psychosis, may be the key to their insight and power. This is in contrast to the more conventional Christian idea that to suggest the saint is not in perfect mental health is to nullify everything else about them. I can only suppose Christians who think like that can have met very few people who suffer from severe mental illness, while failing to recognize mental ill health in its milder forms. The most interesting Christian I have ever met, Elizabeth W., spent long, wretched intervals in mental hospitals. In the periods between such stays she was a wonderful source of life, energy, laughter, humility and love.

It is quite difficult not to recognize when reading Thérèse's autobiography that she was severely neurotic, with a bad case of conversion hysteria (like so many nineteenth-century women). Her mother died, very painfully, of cancer when poor little Thérèse was only four. Her big sisters, who took turns mothering her, abandoned her fairly early on to join the Carmelite convent, and her father was unhealthily besotted with her. She suffered the usual fate of nineteenth-century women, a poor education, and then a forced choice between marriage, spinsterhood or the convent. For Thérèse the choice had seemed obvious from babyhood. She could not wait to get into the convent, and managed to persuade a reluctant bishop to let her enter at fifteen. From this damaged and repressed childhood and youth Thérèse wove for herself a strength, a wisdom, a capacity for love, and even, at the last, a saving cynicism, which I

find moving to think about. But growth for her, as perhaps for Merton in his monastery, led to an inner change which could then not be translated into living. Thérèse died a dreadful death of pulmonary tuberculosis at the age of 24. Merton died of accidental electrocution at the age of 53.

If I feel sympathy for neuroses, it is because I am conscious of my own. The night terrors I suffered as a child, the stammer and my struggles with it, the depression of my adolescence and early adulthood, the fears I have of being emotionally consumed if I enter a permanent one-to-one relationship, as well as other milder and more fleeting fears, all point to early emotional damage, which has not, mercifully, wrecked my life, but at many points has made it less enjoyable and fulfilled than it might have been. My flirtation with Jungian analysis in the 1970s made me feel that the analytic path had something to offer me, if only the satisfaction of an intense curiosity. But I knew I needed a better helper than L., someone certainly wiser, less petty and more intelligent. The right guru does not grow on every tree. In my experience he or she appears once or twice in a lifetime—Joost, I suppose, was the first—and frustrating as it was, I knew I had to wait.

By the early 1990s three people independently had told me of a Freudian analyst, and in 1991 I wrote to her and asked if I might 'have a conversation' with her. I had three interviews with her, at the end of which some important and interesting material had come up. 'You didn't really think we'd dispose of all this in a few chats, did you?', she asked me. She went on to say that she'd largely given up taking on new patients. 'But you do raise one or two interesting lines of thought', she added, rather distantly. Soon I was seeing her three times a week, and then five times a week.

At first I scarcely knew what work it was I wanted to do—perhaps it was mainly the need to have a huge amount of grief attended to. Chaotic emotions—grief, anger, fear—had felt inexpressible around my parents, I think because it triggered their own pain. I worried ceaselessly about whether I wounded N. by telling her of these feelings, which of course indicated how frightening I found them. Very, very slowly I began to trust her to survive whatever I said or felt. This did not come easily, and it was not until I had a very severe attack of 'flu two years into the analysis, and for several weeks

was able to communicate with N. only by telephone, that I was quite sure it was safe to relax into her care for me. It was like jumping into the arms of someone strong enough to take the weight.

Like all analysands, I became entirely obsessed with the process, which sometimes felt very painful and sometimes exhilarating as a dream or a remark opened up some quite new way of looking at my life. I remembered my old doubts about the confessional and the superficiality of its operation; here was a confessional which, so far as was humanly possible, left no stone unturned. When I complained about the pain of it, or the time and energy it consumed, N. would insist that it was a great luxury, by which I think she meant not the self-indulgent navel-examination which some people would certainly say it was, but a unique chance to gain insight about life. When I began to have nightmares in multiples of the fee I paid her, and artlessly told the dream, not perceiving its significance, she substantially reduced my fee.

The process of disinterring ancient memories was often painful, frequently marvellous, and always exhausting. Sometimes I was so tired after a session that I went home and went to bed for the rest of the day. Friends often ask me whether they should have an analysis, or whether I think everyone should have one. Both questions are, in a sense, meaningless. Not everyone would want, or could use, such a process. At another time in my life I could not have used it myself, which perhaps was why I did not find it earlier. I wanted, needed it *then*, and the right person came along. I loved N.'s sharp intelligence, which could make rings round mine. I loved her careful and precise grasp of the nuances of English, her capacity to burst out laughing at unexpected moments, her huge dependability. Whatever may have been going on in her private life, she was always exactly the same—still, attentive, remembering, absorbed, *there*. I even enjoyed her occasional asperity. 'I am not amused', she replied once to a joke I made, clearly intended to convey some momentary hostility towards her. The Queen Victoria touch somehow leavened things.

One of her many endearing qualities was that she believed so passionately in the work she was doing.

The legacy of L.'s fumblings took a little living down.

'I'm fed up with dreams', I said to N. on one of my early visits. 'I'm not at all sure they mean anything at all. I sometimes suspect the

whole thing's a con trick. For example', I went on, 'I had a dream last night about a staircase which had a thick, grey carpet on it, and beneath the grey carpet there was a bit of red carpet sticking out.'

'So what does the red carpet make you think of?', N. asked.

I knew the answer to that right away. 'My grandmother Neni, who lived with us, had a red carpet on the floor of her room. It was called a Turkey carpet ...' The memories started to come back to me. 'When I was about three I used to go into her room and spin round and round in circles until I got giddy and fell on the floor. I called it (here the importance of what I was saying began to get to me) going mad on Neni's carpet. In fact that phrase turned into a family saying. Whenever anyone was under stress they would say "I think I'll just go mad on Neni's carpet".'

There was a long pause and then I remembered, in terrible pain, the row that had taken place between my mother and Neni, my father shuttling helplessly between them, which I think had to do with my mother saying that she could not stand having Neni living with us any more. (Neni was gradually growing senile, though I did not really know that.) I felt Neni's age and frailty, my father's conflict, my own unwitting collusion because Neni mostly looked after me. My memory is of huge adult thighs surrounding me—I was about five—and the colour drained from the scene. I had a sensation of being crushed between these enormous beings. Did I slip into some sort of psychotic state? I rather think I did.

'But, quite properly, you put a good, thick covering of sanity over the whole thing', said N., referring to the grey carpet. So much for dreams being meaningless.

After that, the dreams came thick and fast. I talked a lot about God—God had a way of appearing in my dreams at the time, and I knew him either because his back was turned (to spare me from being overwhelmed), or because he had taken up a disguise so ordinary that only when I began to talk about the dream would I realize that he had been in the dream. I had a fantasy, which shocked N., of God letting me fall over a cliff, and then, as if showing off, catching me a few feet from the bottom. 'Doesn't that seem rather cruel?', N. objected.

There was a dream of a huge figure with his back to me walking across the Norfolk marshes 'sowing' fishes and small aquatic crea-

tures into the dykes. There was a dream of an 'ordinary' man giving a group of us food that we needed—exactly the right food for the needs of each of us. At his left hand was a luminous, ecstatically beautiful, bunch of grapes. There was an outdoor 'classical museum' in Oxford where huge curved antiques, some of them a brilliant turquoise colour like Roman glass, emerged from the ground. Only gradually did I realize in the dream that they were parts of a gigantic woman buried beneath the sand. There was the new house that filled me with delight until I came to a room full of Anglo-Catholic impedimenta—pews, and altars and Gothic gewgaws.

'If I cleared all this stuff away', I thought in the dream, 'it would make a marvellous living-room.' Only in interpretation did I think about the possibility of using the word 'living-room' in its *Lebensraum* sense.

There were many dreams that were full of puns, as well as those amazingly strange sayings dreams throw up. 'Up in the air is the question of circumcision', I remember hearing myself remark in one dream with a strongly Jewish flavour. It seemed quite funny even in the dream.

Among other things, it was clear I was using analysis to understand my relationship to God and to the Church. N., a Buddhist, understood and encouraged me in this pilgrimage, and at one point gave me a quotation from the South American writer Carlos Castaneda, which I have kept framed on the wall ever since: 'For me there is only the travelling of paths that have heart, on any path that may have heart. There I travel, and the only worthwhile challenge is to traverse its full length. And there I travel looking, looking, breathlessly.'

Intrinsic to the religious quest for me was some kind of resolution of my relationship to my mother. In one dream she was smiling at me across a table—I was about four—and I glowed in the light of her love and attention. Then I realized that there was a mirror behind me and that she was smiling at her own reflection.

Very slowly, in the course of the years we worked together, I discovered that I had supplanted my mother in my mind with N., a more dependable parent who could give me the attention I had lacked as a child and so take away my sense of the terrible precariousness of my own foundations. For me this was the most important achievement of analysis.

My speech improved dramatically, and the change was remarked on by many who knew nothing of analysis. This was due less to direct work upon it than, I believe, to the gradual emergence of the painful sense of betrayal by my mother I had suffered in early childhood, and, equally, by the sense of enduring and dependable love that N. gave me in the present ('love' is not a word analysts like much, I fancy, but that is their problem).

My attitude towards my mother had changed a good deal in the five years with N. More and more I could see her as the frail and not very happy old lady she had become, and less and less as the hurtful siren she had seemed to me as a child. It gradually became obvious that her health was failing, and I hoped that if she were to die soon it would be while I was still seeing N. I had come almost to feel that I was marking time waiting for this, and remarked to N. that I felt our work together was nearly finished, but that I wanted to share my mother's death with her.

In the summer of 1985, while I was on holiday in Maine, the telephone call came to say that my mother had died. Within a few weeks I also left analysis, conscious of a stage completed, though much of the point of analysis is that you learn a different way of being with yourself, and continue with it for the rest of your life. I sometimes feel nowadays that I have suddenly got the point of something N. said to me years ago, and am at last ready to work with it.

Within a few days of leaving N. I started writing *Wise Child*, a story of an orphaned child who is taken in by a kindly witch on a Scottish island. The child learns more loving attitudes to the people around her, she has a sense of being one with the wild life of nature, she learns the language—the Language—that underlies everything and which the animals speak, and so discovers her own power. For several years before writing this book I had had a growing passion for standing stones, for ancient sites, and for pre-Christian religious art. I was deeply moved by paganism's reverence for its gods, and for its sense of nature not as an enemy but as the sacred mother who sustains us. As I wrote *Wise Child* I realized how badly I needed some sense of a reconciliation of paganism and Christianity, as if Christianity, cut off from the tap-root of the beliefs that had nourished our primitive ancestors, was wilting because of its alienation from nature.

The idea that Christians may need to examine their prejudices against paganism as part of their own redemption is one that has scarcely surfaced in current Christian thinking, though I think the horror of 'the opposition' for women priests revealed a negative understanding of the whole problem.

Wise Child was a strange book to write, mostly because I had a recurring sense I was reading it rather than writing it, that every time I sat down to work on it I was simply reeling in something that had a complete existence of its own. Very odd. It did well when it was published, but the real importance of it was that it was a kind of love-poem to N. and to the healing powers she shared with Juniper, the witch heroine who befriended Wise Child.

7

Growing old is horrible and dismaying, yet also fascinating. Who is this stranger in the glass who looks so eerily like my mother and my sister? Where did the young idealist go? There are some sharp regrets which sometimes make me groan out loud—either about hurting other people in ways that cannot now be put right, or about unlived life, which I categorize as the great sin (though the greater sin is to waste present life grieving over past failure). What I regret most are things I did not do because I was afraid, yet I am surprised how often such omissions can be redeemed in spite of age. This awareness concentrates me, makes me want to live more vigorously, to travel while I still can, and to write the books I feel within me. In recent years I have worked as a counsellor as well as a writer. Listening to people much younger than myself, I realize the long corridor of the years and the particular perspective it gives on experience—a perspective to be mediated diffidently to those on another part of their journey, battling for jobs.

One of the soothing things about growing old, along with much that is not soothing at all, is that the huge choices of youth—'Whom shall I marry?', 'What work shall I do?', 'Where shall I live?', 'Shall I take up a new career?'—become slimmed down until there is not very much to choose at all. This house, this job, this family, this partner, this retirement is 'it'. Life becomes simplified, whether you like it or not—all you need do is live your life and get whatever joy out of it you can. Since the 'spiritual' view of life is about living the bit of life you are doing with intensity and acceptance, whether of joy or pain—the religious task is to find the meaning of it. Simplification helps that.

There are special gifts of age, of course, too. Seeing one's children grown up, becoming a grandparent, not being quite so obsessed with work.

I think a lot now about my grandparents, and about my parents in old age. I don't think I have the calm my grandparents had—my choices are still too many—but I do like life a lot. The world is tragic, full of catastrophe, yet it is also God-haunted, full of love and grace and jokes which sprout like grass wherever human beings live together, and I am so glad to be part of it all.

Growing old, at least in this early stage, is different for me from the way it was for my forebears. My maternal grandmother died at 56 after years of painfully declining health. Neni died in her late eighties, and, although a capable and intelligent woman until a year or two before the end, assumed that it was the job of her children to take care of her in her old age in turn for her devotion to her grandchildren. Partly because of resenting Neni, my mother was determined to keep her own independence, and did so, right till the end. She was that much nearer to Shaw's 'New Woman'—she had earned her own money and knew the sense of confidence it gives you. (When she first went to work for my uncle—or as people said then, 'went out to business'—her mother insisted that for the first week or two her brother went with her on the train from Richmond, whether from fear she would lose the way or would be exposed to lewd suggestions, I have never been quite sure. It is a glimpse into a different world.)

My own ageing feels different again. I live alone, from choice, not necessity. But I am not a solitary person, though I need time alone; my children and their partners are very important to me, and my friends are vital in making life feel worth living.

I don't think I realized until I began to experience it that ageism—the stereotyping of the old—is a reality. At the doctor's, the very young receptionist explains everything to me in exaggerated detail, though she annoys me more by calling me 'Monica'. How can the use of one's intimate name by a complete stranger be anything other than an act of condescension? In the greengrocer's I can sometimes feel the slight contempt of the shopkeeper when, having forgotten my glasses, I fumble for the change I cannot see in my purse. Suddenly I am seen, and therefore see myself, as an old lady who is losing her marbles. (I should add that I am also touched and moved by the niceness and friendliness of other local shopkeepers, who are an important and valued part of my daily life.) All the same,

the old are in better nick than they were, and this must make a difference to the way we come to think about old age. Some of this undoubtedly is due to improved medicine and nutrition. These make it possible, at least for the lucky ones, to continue to be able to see and hear properly, to be physically active and reasonably fit.

I see that if I am to resist the stereotype it also involves a psychological shift in me. It involves a refusal to sink into inertia, to let my body and mind become lazy and unable to meet new challenges and new ideas. It is not about trying to be young— nothing will ever give back my energy, my smooth skin and my youthful looks—but there is no reason I should not make an effort to look nice, or be capable of interesting conversation.

The attitude of others apart, I want to live as interestingly and excitingly as I am capable of; I am afraid of the boringness I see in the lives of many old people. I don't have huge resources of money, and this cuts down on adventure, but money is not the only resource. I want to go on learning new things, thinking different thoughts, exploring new ideas and maybe being more daring in enjoying the arts.

It must be possible to use old age to shake up my preoccupations and try different experiences – physical as well as mental. It has led me in recent years to try camping, something which I had not done since I was a teenager. Camping on the Scillies, and again on the shores of the Red Sea, made me marvellously aware of the stars, of the sound of the sea at night, of the resources of nature. Too much insistence on elderly 'comforts' could have robbed me of this, and I am glad friends persuaded me that a little discomfort here and there can be worthwhile.

Because in old age I have less responsibility than any time since I was an adolescent, it feels much more possible to take risks of all kinds. The worst that can happen to me is death, and that's on the not-too-far-distant agenda anyway. One kind of risk is to try to get to know people across barriers of race and country and class in a way that once felt too difficult for me. That's one sort of risk, though the worst that can happen is acute embarrassment, an emotion I often felt when trying to get to know Aborigines. For the first time in my life I am worrying less about looking a fool—a peculiarly English dread, I notice.

Not being too worried about looking silly makes all sorts of learning feel easier than it once did. I was struck by the joy of a friend of mine who, retiring at 60, went off to Oxford to work for the degree in English she had not had the chance to attempt when she was eighteen. I would like to be better at languages, to enjoy music more, to know more of science and about the way the world works politically. I am also interested in going to places which once felt dangerous, not from foolhardiness, I hope, but from a need to free myself of fear.

This has to do with the inevitable approach of death. I should be lying if I said I was not afraid of it—I am—though I think it also gives a kind of spice to living. And as I get nearer to it, I feel an immense curiosity about it that is itself a kind of pleasure. What will the process be like? Not nice, I imagine, but something, after all, that the great army of one's forebears have all passed through. But the thought of helplessness, pain, incontinence, especially in a health service shorn of money and staff, frightens me as it frightens everyone. If a wartime youth taught me anything, however, it was not to waste too much energy in revolving a variety of horrible (and incompatible) alternatives. Maybe the only thing to be afraid of is fear. As a friend of mine once remarked, 'If you die by impaling you are at least spared being buried alive'. I like this sort of black joke, and was cheered by it.

And after death, what? Perhaps because I have listened a lot to near-death experiences, or maybe because I believe in the world's endless capacity to surprise (or maybe just because I want to believe it), I find I do believe that death is not the end. I cannot imagine non-being. I see very well, indeed I *experience* the way the Resurrection story is about an everyday psychological truth—the way life springs again out of tragedy, pain, loss, disappointment—but I don't see why it must be restricted to this. Myth works and teaches on many levels, and we are right to note its ambiguity, but I wonder why many Christians now feel such a need to go for the dullest possibility? Perhaps for the stoical reason that they would really like life after death to be a reality, but are steeling themselves for disappointment. It is easy to mock some of the old imagery—casting down one's golden crown around the glassy sea, for example—but there was a nobility in the hope of life after death.

Particularly moving is the sense of old wrongs being righted, and of the sinners being forgiven. My favourite image of the Resurrection is Mantegna's *Harrowing of Limbo* in which three pale, etiolated figures—two of them Adam and Eve and the third, I think, must be Judas—emerge from the shadows into the sunlight summoned by Christ. We cannot see Christ's face—he is looking down into the shadows, but in contrast to those being redeemed, he is a powerfully energetic figure. We know something of the expression of his face from the reflection and intolerable hope on the faces of the three. We may not be very dramatic sinners, and we may not have been very dramatically sinned against, yet the idea of forgiveness for our failures and healing of our wounds, and of the forgiveness of others who have wronged us, is a rich one. There seems a need for a cleansing of our appalling mistakenness.

One of the things in old age which continually brings home the thought of death is the loss of friends and relatives. The death I have minded most has been that of Ron Eyre, who died of lymphoma in 1992. I have missed very much a particular quality he had of understanding me and of speaking 'my' language, though he sometimes used his understanding in destructive ways. I miss, too, the sudden flashes of insight he gave me into plays and films. I remember standing with him in the Kunstmuseum in Vienna and, as a result of his comments, seeing that Velázquez painting of the Infanta in her blue dress (which I had secretly always found boring) as a sort of revelation. In the same museum he forced me to examine Brueghel's *Children Playing Games* in detail just because he enjoyed it so much. We went for a long snowy drive along the little villages of the Danube—Ron making up scurrilous words to 'The Blue Danube' and singing them aloud—pausing to look at wonderful Baroque churches, and lunching in a smoky tavern. Now all the wit, the insight, the laughter is gone, together with a shared passion about religion.

One of the things I shared with Ron was recollection of growing up at the same period. For both of us the War was a crucial part of our childhood and adolescence. Both of us knew the oddities of the English class system as filtered to us by the grammar school. Both of us had had much of our cultural education from the wireless (we often used to test one another on old radio programmes: 'Hum the

Monday Night at Eight tune.' 'What was *Monday Night at Eight* called before it was called that?' 'Who were the characters in *Happidrome*?', etc.). We also used to discuss school set books that we had read for examinations, plays we had seen years before we knew each other, and Hollywood films.

The pleasure for which the elderly are famous is the pleasure of the past, the past in which books, or stories, or films are experienced with a wonderful freshness, the freshness of a mind uncluttered with knowledge and experience. For a time, memories, and places, such as my grandparents' house in Richmond, or the house where I lived as a child, could move me almost unbearably because of the sense of irretrievable loss they gave me. I suppose it was partly that I would have liked to have lived parts of my childhood over again, or to re-experience that childhood sense of being taken care of. Now I wonder if the sense of grief is necessary. It seems more as if the moment—the moment of vision or beauty or understanding or love—is as much alive now as it was then.

One thing advancing age has impressed on me is the pleasure of the 'dailiness' of life—the routines, the tastes, the sights, the seasons, the comforts. Did I enjoy them so much before when the prospect of them seemed to stretch before me for ever? I don't think I did. But what dailiness reminds us is that it is our job to get on with our lives, to complete our life-span. I can't wait.

Epilogue

A single life is not much material from which to try to understand something so vastly complex as the world, and yet it is all that we have—this brain, this body, this pair of eyes and ears, this very limited experience bounded by genes and capacities and knowledge. It is with this limited instrument that whatever we understand by meaning must be appreciated and assessed. Just as God, in the Christian myth, is mediated to us by one human being, Jesus, so life is mediated to us by the particularity of one life, our own. Perhaps it is the particularity which gives the experience such intensity, like a glass focusing the rays of the sun.

The interaction of the myth with our life is our experience of God, and in attempting to look at some of the experiences that have been important to me in my life, I have been very aware of how the myth shaped me, mostly bringing a sense of meaning that sustained me, occasionally making me more fearful, bound by dangerously narrow proprieties. When living faith, and powerful interaction with the myth, dies in us, then propriety is apt to creep in in its place like a deadly parasite.

But mostly I have been enriched by my contact with religious believers. I feel an immense gratitude for those who in their own religious struggles had the courage to strip away travesties and distortions of the myth, and so helped to make it alive for me. A word, an article, a joke, an expression, a book, an act of kindness or goodness, can become a flash of truth that lights up a world previously unseen. Sometimes the capacity of others to love me—to perceive me or understand me without a wish to clutch me or possess me—has had the same effect. 'Jesus' is the shorthand for these moments when, like the Bird of Paradise, religious truth becomes present to us.

For me the background to the moments of 'Jesus' is the sense of oneness with the natural world I knew so well as a young child, and much more occasionally as an adult. To experience this at all is to find the world transformed and to know joy, maybe ecstasy. Although this experience may not come to any of us very often, I believe most people have known it at some time in their lives. It is more dynamic than happiness; it is more like Julian's 'All shall be well . . .'.

If most of us experience joy, most of us also know about pain. Pain often seems an unanswerable conundrum—for those whose myth is of a loving God, that is—and it often rouses us to anger. Yet we may come to think like the Greeks that God, or the gods, are present in the suffering, in Christian terms God is hanging on the cross of contradiction, and that life flows from this dark mystery.

> pleasure and pain are merely surfaces
> (one itself showing, itself hiding one)
> life's only and true value neither is
> love makes the little thickness of the coin
>
> e.e. cummings

I would think this rather glib except that when I have been very unhappy I have often had a similar insight, as if sorrow and joy turned inside out and became each other.

The Christian myth reaches into the depth of sorrow, with the God-man experiencing the physical agony and the mental degradation that so many human beings experience, as if he is entering, imitating, the most painful dimension of being human, plumbing it to its unspeakable depth. In the Resurrection, in contrast, the myth speaks of the highest rapture, the fullest joy.

> There is a new morning, and a new way,
> When the heart wakes in the green
> Meadow of its choice, and the feet stray
> Securely on their new-found paths, unseen,
> Unhindered in the certain light of day.
>
> There is a new time, and a new word
> That is the timeless dream of uncreated speech.
> When the heart beats for the first time, like a bird
> Battering the bright boughs of its tree; when each
> To the other turns, all prayers are heard.

There is a new world, and a new man
Who walks amazed that he so long
Was blind, and dumb; he who now towards the sun
Lifts up a trustful face in skilful song,
And fears no more the darkness where his day began.
> James Kirkup, 'There is a New Morning' from 'Six Poems to
> Jules Supervielle' in *A Correct Compassion and Other Poems*
> (Oxford University Press)

So we may feel, as we eventually recover from an operation, a bereavement, a mental illness, a blow or shock of some kind, finding, against all the odds, the resurrection that makes it possible to start living again. Other aspects of the myth, if we choose to work with them—the Annunciation, the Nativity, the sayings and parables, the Ascension, the accession of power at Pentecost—speak to other forms of the struggle to understand our humanness.

There is also a huge secondary accumulation of myth—Arthurian legend, quest stories like *Parsifal* or *The Pilgrim's Progress*, stories as in the opera *Billy Budd*, or Patrick White's novel *Riders in the Chariot* where the idea of spiritual journey is explored or the Christ myth is refound in a contemporary man or woman.

The myth is our 'sacred place'; it needs our attention, our empathy, our love, our willingness to dream dreams and see visions in the light of it, and to undergo the transformation it requires of us. From some, perhaps, it requires satire, scorching words, even blasphemy, to peel off the layers of familiarity and self-satisfaction and open us to the change that frightens us.

This is all quite different from a chauvinistic Christian conviction that our myth is 'the truth', bigger and better than someone else's truth—like one's Dad's car when one is seven years old. When the myth becomes a cause of boasting, or for giving us superior feelings, then we have already lost sight of it. We may, however, recognize that the myth we have inherited, been seized by, or stumbled into, is a very remarkable one, which can offer an interpretation of life that is rich and flexible and deeply satisfying. It is our job to cherish it.

But what if the myth is dying? For many in what was once the Christian West the gap between life and myth has become large, and probably nearly all of us are aware of some split within ourselves. We recognize the power of the myth at times yet also feel as if we have

lost our voices in trying to speak of it. The dryness of our theology, the lack of vision and direction in the churches, the folly in holding a Decade of Evangelism when our voice is so uncertain, make it tempting to despair.

Rather like the famous scene in *Peter Pan* in which the children are asked to clap to keep Tinker Bell alive, we must clap if we want to keep the Christian myth alive, or rather we must give it our generosity, our love and our imagination. (I remember a very small child at *Peter Pan* not merely clapping but standing up and shouting in an agony of concern 'I believe!') It is not, of course, that we must pretend to believe in what we do not, rather that, like the child totally caught up in love for Tinker Bell, or like an actor finding the character he or she is playing deep within, we have to find crucifixion and resurrection already present within us and live out of that knowledge. Then it might be possible to leave our nostalgia for the Christian past, and set out once more, with originality, daring, courage, on a new sacred quest to see what the myth means as we approach the twenty-first century.

Of course, we shall only see it fleetingly, a glimpse of the Bird of Paradise, but that is all we need. Without such glimpses we shall die of directed thinking, and the myth, with all its clues as to who we are and how we might live our lives, might no longer be apparent to us.